T16

D1156177

VICTORIAN AND EDWARDIAN PHOTOGRAPHS

Victorian and Edwardian Photographs

Margaret F Harker
Hon FIIP Hon FRPS Hon FBKSTS DGPH

Charles Letts Books Limited

To my husband, Richard Farrand

Visual Studies Workshop
Research Center
Rochester, N.Y.

March 9, 1988
S. U. N. Y. - Brockport

The author would like to express her gratitude to the
acknowledged friends who have so kindly loaned items
from their own collections for reproduction as illustrations.
Thanks are also due to the Royal Photographic Society

First published 1975
Revised edition 1982
by Charles Letts Books Limited
77 Borough Road, London SE1 1DW
Illustrations photographed by Margaret F Harker and Brian Nicholls

© Charles Letts Books Limited

All rights reserved. No part of this publication may
be reproduced, stored in a retrieval system, or
transmitted, in any form or by any means, electronic,
mechanical, photocopying, recording or otherwise,
without prior permission of Charles Letts Books Limited

ISBN 0 85097 369 4

Printed and bound by Charles Letts (Scotland) Ltd

Contents

Introduction

VISUAL IMAGERY in the form of photography was made possible by two inventions made public in 1839. The two forms, daguerreotypy and calotypy, different in nature and characteristics and easily identifiable, were both slow in response to light and could only record static subjects. Later developments and inventions have so extended the scope and range of the medium that objects too small, too distant, and too fast or slow moving to be seen by the human eye can be recorded by means of photography.

Photography is a remarkably adaptable medium. It can be used for factual and accurate recording, for illustration, for pictorial representation, for the expression of ideas in either realistic or abstract form. Cinematography was developed from photography and television employs photographic systems. Photographs are to be found on metal, wood, glass, ceramics, enamel, leather, ivory and textile fabrics, as well as on paper, and in three dimensional form as in holography.

The growing public interest in old photographs is reflected in the allocation of resources to the major collections, Arts Council sponsored exhibitions, television programmes on collecting antiques and the history of photography, and the high prices paid for the oldest and rarest examples of photographic imagery.

The most extensive and well organised collections of old photographs are established in museums, art galleries and libraries in Austria, Britain, France, Germany, Italy, Scandinavia, Switzerland and North America. There is evidence of increasing interest in other countries, particularly in Australia, Japan, Russia, and Yugoslavia.

Private collectors are far more numerous than was the case ten years ago. Prior to that antique dealers sold Victorian picture frames but discarded the contents if they were photographs. Quantities of interesting and historically valuable material were removed from attics and destroyed.

The collecting of old photographs can be a fascinating pursuit and can be pursued by those of modest means as well as by the wealthy who collect for investment purposes. The aim of this book is to guide the beginner and provide basic reference for the more experienced collector. Aesthetic value and documentary significance is by no means always reflected in the prices at sales of old photographs.

Photographs are collected for several different reasons. Art collectors and photographers are interested in the different processes and their applications as well as in the fine qualities, unusual characteristics or rarity of the imagery. Other collectors may be primarily concerned with the documentary value of the photographs and the insight they give into Victorian dress, manners, customs, entertainment, modes of travel, or Edwardian fashions, famous

beauties, and distinguished men of the period. Changes in the environment (natural and man made) over periods of time are particularly well revealed in photographic imagery.

Serious collectors are well advised to concentrate on fine images by photographers who have proved themselves as artists using a camera in place of a brush. A knowledge of the history of photography (see Bibliography) as well as a study of the work of individual photographers will help considerably. The works of the most distinguished photographers now command high prices in the major auctions. Sales in 1981–2 included MacPherson's Photographs of Rome (40) in album for £2,600; a portrait of Julia Margaret Cameron with her two sons for £950; The King's Arms at Omberley, 1850's, by Benjamin Bracknell Turner for £450; a single issue of Camera Work, number XIX, 1907, with photogravure plates (6) from photographs by Craig Annan and Steichen for £140; Cattle on the Marshes, a platinum print from Life and Landscape of the Norfolk Broads by P H Emerson for £110; The Old Closes and Streets of Glasgow with fifty photogravure plates from photographs by Thomas Annan for £220; 'Undine', a toned silver print, by Herbert Lambert, c1923, for £35; a landscape of a water-fall by Frederick Evans, c1900, a platinum print, for £185; The Drawing Room, a stereo daguerreotype, late 1840's by Antoine Claudet for £320.

A determined search, outside of auction houses, can be rewarding but less material of really fine quality is now available than was the case ten years ago. Collecting old photographs is very different from collecting paintings: each painted image is unique whereas several photographic prints have usually been made from each negative. Indeed, it is not unusual to find that a number of negatives closely resembling each other have been made of the same subject. Daguerreotypes and ambrotypes are exceptions because they are direct positives and therefore are unique images.

Those with a very limited budget need not despair as good examples of photographs by commercial photographers, such as the View Card companies (Frith, Valentine, Washington Wilson, Judge) and the London stereoscopic company, as well as portrait studios such as Basano, Lafosse, Downey, and Van Dyck, to mention but a few, produced good quality photography and some fine and interesting imagery. These items can be acquired through dealers and curio shops for reasonable prices.

Because of the quantity produced and the anonymity of the photographer in so many instances, good examples of daguerreotypes, and ambrotypes, can be acquired for a comparatively modest outlay (£8 to £80 each dependent on quality, size, rarity, and period, though images which are attributed to a particular photographer usually fetch the higher prices). However, some of these images are very crude, revealing lack of taste as well as skill in the photographer. Careful study of the image is therefore imperative before making a purchase.

Cartes de visite and cabinet size portrait prints are obtainable from antique market stalls and other dealers. Stereo pair cards have been abundantly available in recent years but an increase in interest currently is likely to reduce those in circulation. Prices for cartes and cabinet prints are still very reasonable.

Daguerreotypes 1839–c1860

THE DAGUERREOTYPE process was developed and published by L J M Daguerre of Paris in 1839, subsequent to the death of his partner, J N Niépce in 1833. The latter had invented heliography (a very slow method of obtaining a sun picture which formed the basis of later developments culminating in photo-mechanical printing), and produced his first successful photograph in 1826.

A daguerreotype is a direct positive photographic image when viewed directly; when held at an acute angle a negative image can be seen instead. It is a unique image like a painting. The surface is like a mirror as the image support is a copper plate coated with silver which is then highly polished. Immersion in distilled water and nitric acid, followed by subjection to iodine vapour, rendered it light sensitive. Initial exposure times were from two to twenty minutes (dependent on image size, weather, time of day or year) until improvements to the process in 1840, and the use of concentrated light when making the exposure, reduced exposure times to between five seconds and two minutes. After exposure the plates were subjected to mercury vapour which revealed the image which was then fixed with a solution of common salt or hypo.

A daguerreotype image is extremely delicate, the process affording remarkably fine rendition of detail. Although used initially for photographing still life, landscapes, buildings and archaeological sites, daguerreotypy became particularly popular for portraiture once exposure times were reduced. It was in widespread use in Europe and America between 1839–1860, although its popularity declined in Britain and France after 1855 due to the invention of the collodion process.

Gilding or gold toning, recommended by Fizeau of France in 1840, made the image more durable, and increased contrast and strength of image.

The practice of colouring daguerreotypes was introduced in Britain in 1842 by Richard Beard. It was a delicate process and demanded great skill in applying dry powder colours mixed with a little gum arabic which was either shaken onto the image over a stencil or applied directly with a fine camel hair brush. The colours were fixed by breathing on the plate.

In order to prevent deterioration by sulphur compounds in the atmosphere and protect the delicate surface from abrasion, daguerreotypes were bound with a cover glass with a thin gilt brass matt between the plate and the cover. Where the protective cover has not been adequate, the silver will be tarnished, usually around the edges of the plate. This can be removed by appropriate treatment but it is best left to an expert.

Daguerreotypes of the later period were placed in a delicate pinchbeck (or similar metal) frame. Frames and matts are of various designs. The complete item was presented in a velvet or silk-lined display case usually made of wood covered with morocco leather, or papier-mâché embossed with floral, fruit or geometric motifs, or thermoplastic moulded into many different and delightful designs which portray human and animal figures, flowers and fruit or more formal geometric shapes. The latter were called Union cases and are collected for their own sake in addition to the daguerreotypes or ambrotypes they

contain. Portrait daguerreotypes were also made up into lockets, brooches, and rings.

To a large extent daguerreotypy supplanted miniature painting which it was thought to resemble closely. It was considered more accurate, took less time, and was less expensive. Richard Beard charged from one to four guineas according to pose and size. The majority of portrait daguerreotypes were produced in small sizes: one fourth plate ($3\frac{1}{4}'' \times 4\frac{1}{4}''$), one sixth plate ($2\frac{3}{4}'' \times 3\frac{1}{4}''$), one ninth plate ($2'' \times 2\frac{1}{2}''$), and one sixteenth plate ($1'' \times 2''$). Most daguerreotypes are non-attributed due to patent restrictions. Some of the accredited daguerreotypists who produced fine quality images were:

Britain: Beard, Churchill, Claudet, Kent, Kilburn, Howie, Jabez Hughes, Malby, Mayall, Paine, Telfer, Whitlock

France: McCaire, Bisson Frères, Derussy, Lerrebours, Plumier, Thierry, Vaillat, von Martens

Germany: Biow, Stelzner, Braun (Alsace)

U.S.A.: Anthony, Brady, Broadbent, Gurney, Langenheim brothers, Lawrence, Root, Southworth and Howes, Whipple.

The majority of daguerreotypes portray an adult facing the camera in three quarter length, including the hands, or in head and shoulder pose. Children presented more of a problem and are usually portrayed in rigid poses and with unsmiling expressions. Groups of two or more people are less usual and likely to have been made during the late forties or fifties.

2 A STEEL ENGRAVING by the London Printing and Publishing Company from a daguerreotype by Paine of Islington, *c*1844

3 A PAIR OF DAGUERREOTYPE PORTRAITS IN PRESENTATION CASE by Churchill *c*1847. One fourth plates ($3\frac{1}{4}'' \times 4\frac{1}{4}''$). The female portrait is delicately colour tinted

4 ASSEMBLY OF PRESENTATION CASES USED FOR DAGUERREOTYPES AND AMBROTYPES. The two above are Union cases (thermoplastic), the open case (leather) contains a one ninth plate ($2'' \times 2\frac{1}{2}''$) daguerreotype *c*1845, the one in the centre is of leather, those at left and right are papier mâché

3

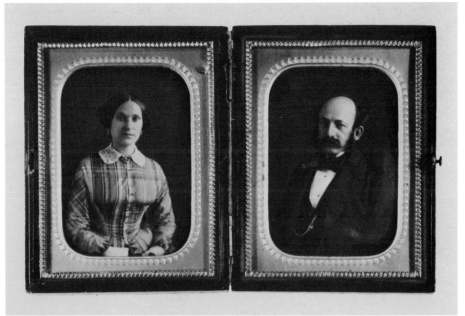

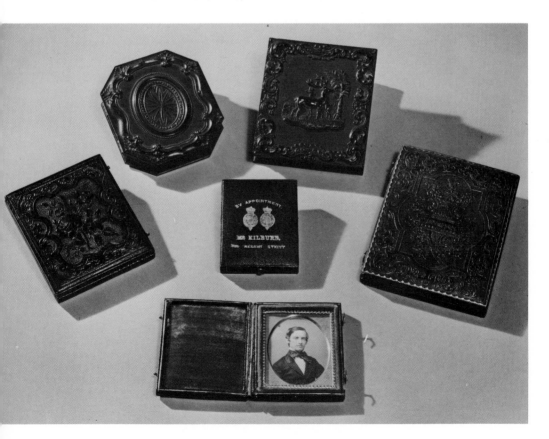

11

Calotypes (Talbotypes) 1840–*c*1864

THE CALOTYPE process was a modification of PHOTOGENIC DRAWING, both of which were invented by W H Fox Talbot, an English country squire who was a distinguished mathematician and scientist. He announced his invention of photogenic drawing in 1839. The great significance of his inventions was that they were a negative-positive method of producing photographs so that any number of positive prints could be made from the master negative.

Calotypes are paper negatives. A fine smooth-textured writing paper was sensitised to light with a solution of silver iodide and followed by a wash of gallo-nitrate of silver immediately before making the exposure. When dry the sensitised paper was exposed in a camera (portrait exposures ranging between thirty seconds to two minutes, and the larger papers used for landscape work requiring exposures of between one to five minutes), then the latent image was developed with gallo-nitrate of silver solution, fixed with hypo and washed.

Prints were made from the negatives on a 'print out' silver chloride paper, similar to Talbot's photogenic drawing paper of 1839. The sensitised paper was exposed to sunlight in contact with the negative in a printing frame for fifteen minutes to an hour and the image fixed in hot hypo solution.

Calotypes are comparatively rare and they should be handled with great care. The silver chloride prints made from the negatives have a somewhat coarse appearance due to the paper negative fibres, and in consequence lack fine rendition of detail. Many have faded (at the edges if not over-all) and there is a risk of further fading if handled in bright light conditions. It is a wise precaution to examine them in subdued daylight or weak tungsten light for a minimum time and store them in acid free containers in an atmosphere which is not too hot, too dry, or too humid. They are red-brown or sepia in colour or yellow if badly faded. The surface is matt with a very slight sheen. The image can be improved but it is advisable to consult an expert. During the later period during which calotypy was practised, prints were made on albumen paper.

Several leading photographers, around 1852, adopted the practice of waxing their paper negatives to improve definition and make them more translucent for printing. Prints made from these negatives do not have a fibrous appearance and more closely resemble prints made from glass plate negatives.

Paper as a support for negative images was re-introduced about 1882. These negatives should not be confused with calotypes. Subject dating will assist identification.

Calotypes were made in various sizes; half plate and $5'' \times 7''$ being popular for portraiture and upwards of $8'' \times 10''$ for landscape, architecture, and the copying of paintings. All prints were made by contact with the negative. They were displayed in albums and sold loose so that they could be mounted or framed according to choice. The process was more popular with amateurs than professionals in the early years. Some of the leading exponents were:

Britain: Rev George Bridges, Philip Delamotte, Dr Hugh Diamond, Roger Fenton, Vernon Heath, D O Hill and R Adamson, Robert Hunt, Dr Thomas Keith, J D Llewellyn, John Shaw Smith, Thomas Sutton, and Fox Talbot himself.

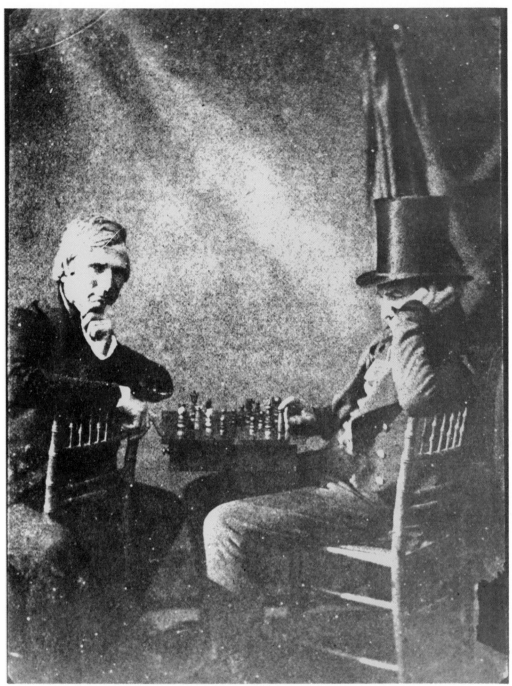

5 CALOTYPE (TALBOTYPE) *The Chess Players* by William Henry Fox Talbot *c*1842, $5\frac{3}{4}'' \times 7\frac{1}{2}''$. It was taken outdoors in sunlight, the exposure being 2–3 minutes. The player on the left is Antoine Claudet. There are two known versions, the others showing the players reversed. (Claudet on right) in different attitudes. *In the collection of Harold White* FIIP FRPS

France: Hippolyte Bayard, Eduard Baldus, E Becquerel, Bisson Frères, Maxime du Camp, F Flacheron, Gustav Le Gray, Charles Marville, Charles Nègre, H V Regnault, Henri Le Secq.

U.S.A.: The Langenheim brothers were the only professionals to practise calotypy in America, having purchased Talbot's patent in 1849.

6 CALOTYPE (TALBOTYPE) *The Fruitsellers* by William Henry Fox Talbot *c*1843, $7\frac{1}{2}'' \times 5\frac{3}{4}''$. It was taken in the cloister enclosure of Lacock Abbey. The seated figure is probably Talbot's wife, Constance, and the standing figure on the right his mother, Lady Fielding. *In the collection of Harold White FIIP FRPS .*

Photography by the Wet Collodion Process 1851–*c*1886

FREDERICK SCOTT ARCHER invented the method of making photographic images on glass by using silver halide salts incorporated in collodion, resulting in greatly increased light sensitivity. Quarter plates and smaller yielded well exposed images in two to twenty seconds, and the larger plates used for landscapes, architecture, and by some portrait studios required between five seconds and two minutes according to conditions (outdoors, indoors, time of day and year, aperture of lens diaphragm, size of plate). The exposure had to be made whilst the collodion film was still moist (it lost sensitivity when dry), and the plate developed and fixed immediately afterwards. It became necessary for photographers in the field to carry dark tents with them. Thomas Annan of Glasgow purchased a hansom cab and blacked out the apertures in order to photograph country houses and their contents in his locality.

The excellent rendition of detail as well as increased speed and the adaptability of the process (the collodion could be transferred to other surfaces because of the toughness of the film, or processed to a positive instead of a negative) made it very popular. British portrait photographers quickly discarded daguerreotypy in favour of collodion.

Ambrotypes (Glass positives) 1852–*c*1880

By giving minimal exposure so that dark shadows were transparent, developing the image in a solution formulated to give highlights an opalescence, then backing up the collodion image with black velvet, a sheet of smoked glass, brown varnish, or black japan lacquer, the photograph could be presented as a direct positive image.

Ambrotypes were substitutes for daguerreotypes and were cheaper and much easier to produce. Images can be seen more clearly although they appear dull when compared with those on silvered plates. The increased speed of the process permitted greater flexibility so that ambrotypes by the best photographers show more relaxed poses in a greater variety of attitudes, more ambitious settings, and expressions which are less tense and strained. Unfortunately for the art a large number of less skilled practitioners set up in business so that a high proportion of ambrotypes do not reflect this advance.

Subjects included landscapes and buildings but 'likenesses' were in greatest demand. Some morbid Victorians requested death-bed portraits. Groups of people were photographed together, and occasionally animals were included with their owners. Later in the century ambrotypes were taken in more casual outdoor settings such as gardens, beaches, and funfairs, but the majority of ambrotypes in collections or circulation indicate that most subjects were photographed in photographers' studios.

Colour tinted ambrotypes were not unusual, quality varying according to the standards of the photographer. Some are exquisitely coloured in oils, water-colours, wax crayons, or powders, others crudely done. Many ambrotypes have deteriorated in the course of time, either suffering from mosaic cracks (a weakness to which collodion was prone), flaking of the japan varnish backing, or moisture invasion of the image which leaves mould growths or water ring marks at the edges of the plate.

15

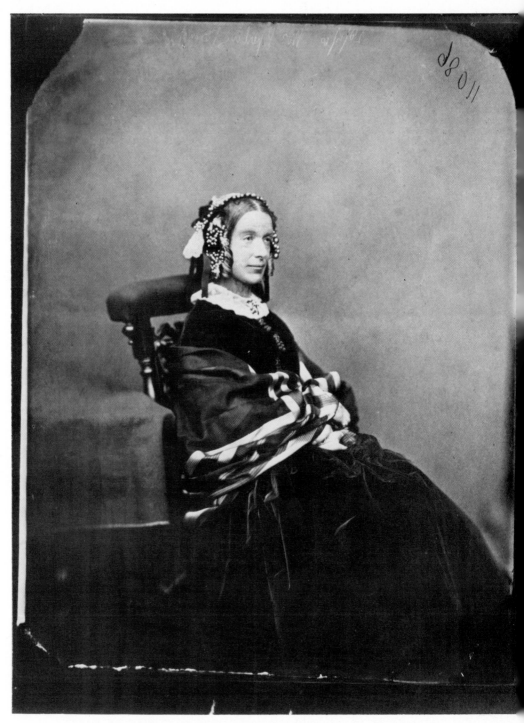

7 SALTED PAPER PRINT FROM WET COLLODION NEGATIVE *Mrs Sperling* by photographer unattributed, 1860, $6\frac{1}{2}'' \times 8\frac{1}{2}''$. Uneven coating at edges of plate denotes collodion process. The mirror image of 11086 is the photographer's file number

Like daguerreotypes, ambrotypes were enclosed with a gilt matt in a pinchbeck type frame and inserted into a presentation case. Some of these charming cases were designed to hold two ambrotypes, face to face, so that portraits of husband and wife or of two children could be viewed as a pair; an alternative form of presentation was intended for displaying the ambrotype on the drawing room wall. The photograph, in *passe-partout* mount, was inserted into either gesso-decorated or carved wood frames. If the collector is fortunate he will find the photographer's publicity notice on the reverse of the frame, sometimes in verse.

8 AMBROTYPE ASSEMBLY including a complete ambrotype in case ($\frac{3}{4}$ length portrait of young man seated) c1856. On the right is an unbacked image on glass plate, with pinchbeck type frame and matt. On the left is an image partly backed by black velvet to show translation to positive from negative (lower portion of image), and a complete ambrotype

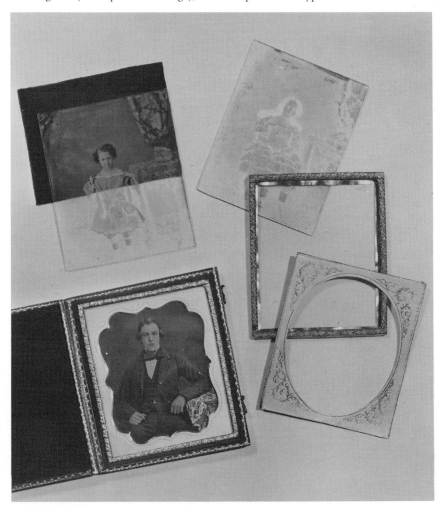

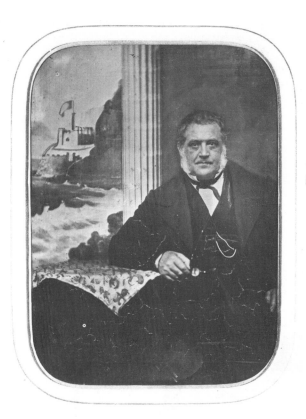

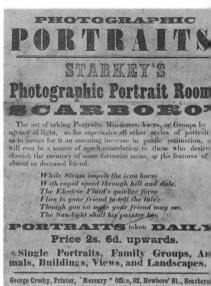

9 AMBROTYPE portrait of man by Starkey of Scarborough, *c*1856. Part colour tinted, varnish backing cracked in lower half. Whole plate ($6\frac{1}{2}'' \times 8\frac{1}{2}''$) presented in frame for wall display

10 STARKEY'S PUBLICITY NOTICE pasted on the reverse

Tintypes, alternatively known as Ferrotypes (Collodion positives) *c*1856–*c*1940

Black or dark brown enamelled sheet iron in a thin gauge was used as a support for the collodion film which, when exposed and treated in the same way as for ambrotype production, gave a direct positive image. The tintype was invented by Hamilton Smith, an American. Requiring the least skill of all comparable processes, it became popular with those producing cheap photographs and the growing band of itinerant photographers. The material could be cut to any shape or size and tintypes were collected in albums, having been inserted in cheap paper mounts, or into brooches, rings, lockets, and other small articles. Although in most instances the images are poor, photographically speaking, many are especially interesting in the social sense in that they record the appearance, customs, dress, and leisure activities of those who could not afford the the better forms of photographic imagery. The better tintype images, in the main, were by American photographers who had a wide ranging clientele and with whom the process was more popular than with their European counterparts. Subjects were diverse and images reveal informal and casual grouping as well as formal posing. In Britain and other European countries beach and street photographers set up their cameras at seaside resorts and in market squares. The whole process was carried out on the spot and the finished result, still moist,

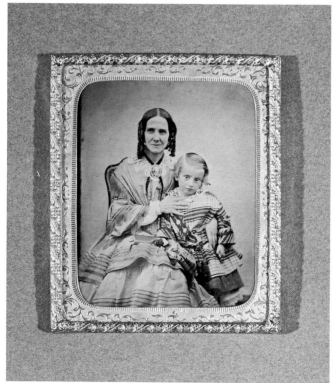

11 COLOUR TINTED AMBROTYPE of mother and child by unidentified photographer *c*1853. One sixth plate ($2\frac{3}{4}'' \times 3\frac{1}{4}''$)

handed to the client. This practice was continued to the mid–twentieth century. Tintypes are easily recognisable unless they have been framed and glazed, in which case they can be confused with ambrotypes.

Albumen Prints 1850–*c*1895

This 'print out by contact with the negative' process was undoubtedly the most popular during the collodion period. Light sensitive silver salts in albumen (white of egg) formed a coating on quality, translucent paper. The image was formed on the surface of the paper. Albumen prints have a glossy appearance, are fragile and crease easily. They are sepia (yellow if faded) or rich plum colour if gold toned. The toning helped to preserve the print from fading by light or chemical action. Fine detail is reproduced particularly well by this form of photographic print.

Print size varied, whole plate ($6\frac{1}{2}'' \times 8\frac{1}{2}''$) and $8'' \times 11\frac{1}{2}''$ being particularly popular for topographical views and architecture. Large quantities of albumen prints were sold by print-sellers and bookshops, as postcards are sold today. *Collodio-Chloride Paper* (POP ie print-out paper) *c*1880–*c*1940 eventually re-placed albumenised paper for contact printing and was used, latterly, by professionals for proof printing.

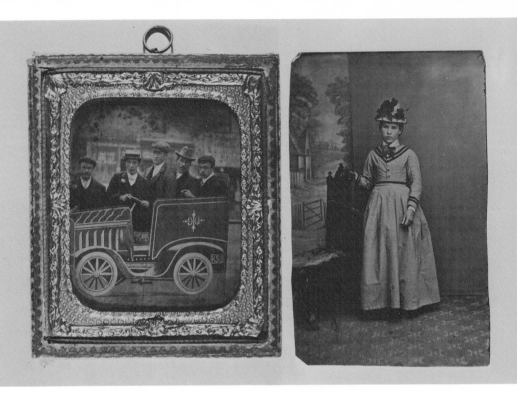

12 TWO TINTYPES late 1870s. The one on the left, one sixth plate ($2\frac{3}{4}'' \times 3\frac{1}{4}''$), was taken in a typical funfair location, the one on the right ($2\frac{1}{2}'' \times 4''$) in a commercial portrait studio

13 TWO LATE AMBROTYPES *c*1876, taken at sea-side locations, possibly Brighton. Both are one sixth plates ($2\frac{3}{4}'' \times 3\frac{1}{4}''$)

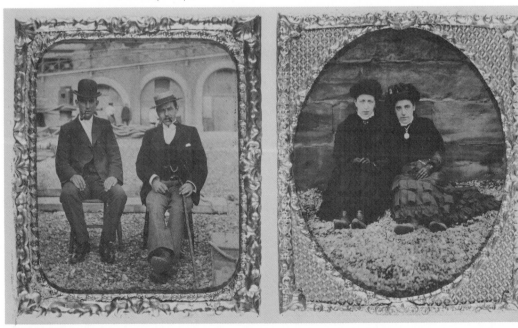

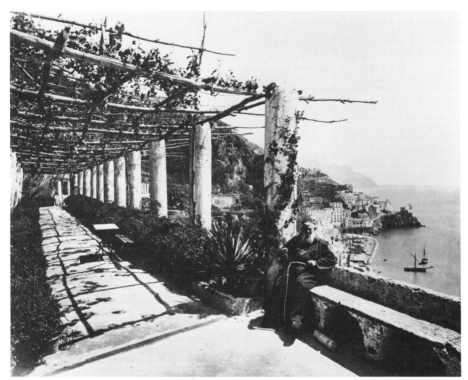

14 GOLD TONED ALBUMEN PRINT FROM COLLODION NEGATIVE *Amalfi'dal Grand Hotel dei Capuccini* by Sommer of Napoli, *c*1876, 10″×8″. A typical photograph of a place. Prints were sold loose for insertion in travel albums in the 19th century

15 GOLD TONED ALBUMEN PRINT *Llandudno Bay and Parade, North Wales* by Francis Bedford, 1868, 11″×7½″. An interesting topographical study to compare with later photographs from this point

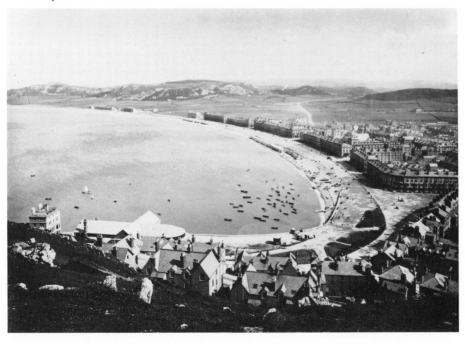

Cartes-de-Visite 1859–c1905

These visiting card size photographs (the majority of which were portraits but views and architectural subjects were also producd) were exceedingly popular. Four lens cameras capable to taking eight images on one plate were used. From the contact print the eight images were cut and pasted onto specially printed cards bearing the name and address of the photographer on the back. The earlier images are printed on albumen paper, later ones on gelatino-chloride paper or by the carbon printing process (see p45).

'Cartomania', as it was called, was a Victorian collecting craze and compares with stamp collecting in this century. Photographers invited eminent people to their studios and were patronised by the Royal families of Europe. These cartes, sold through printsellers and other vendors, were produced in their thousands. Elaborately decorated albums, with coloured stencils or transfers featuring flowers and countryside views, with tooled leather covers and gilded edge boards containing apertures for the insertion of the cartes, were produced for the Victorian drawing room. Some incorporated musical box mechanisms. Avid collectors inserted cartes of themselves, their families and friends, as well as photographs of royalty, and distinguished men and women of the day.

Cartes-de-visite are the most readily accessible of old photographs and can be among the cheapest to acquire. The images are fascinating, informative, and excellent records of dress, hair styles, and ornaments of the period. Many of the most celebrated photographers of the time included cartes amongst the range of photographs they offered, so that a careful scrutiny reveals big differences in the portrayal of people —from aesthetically pleasing to inferior imagery.

Generally speaking the earliest cartes were the simplest, featuring full length figures either standing or seated against plain or classical backgrounds. Later, photographers introduced a range of props into the studio including painted backdrops of outdoor scenes, wooden structures to resemble arbours and stiles, and even large rocks and small boats. A vignette treatment was popular with some photographers who photographed their clients' heads and shoulders, merging the shoulder line into a white background.

Between 1868 and 1914 other popular print forms made their appearance. The CABINET PRINT was produced in large numbers towards the end of the century and albums included apertures for both carte and cabinet prints or for the latter exclusively. PROMENADE, BOUDOIR, PANEL, and COUPON prints became available, as well as POSTCARDS which swiftly gained popularity and eventually dominated this market. Initially postcards were made by photographic printing methods until the invention of photomechanical reproduction. It is interesting that 'real photograph' postcards were still being produced in the 1950s.

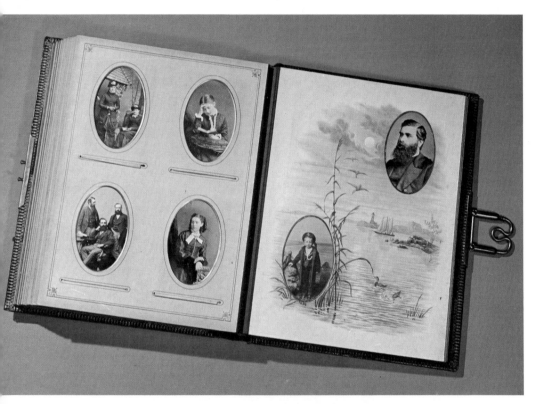

A CARTE-DE-VISITE ALBUM c1875. Brown moroccan leather covers with part plain
art gilt tooling, gilt-edged boards, 9″ × 11″. Colour transfers of Scotland's lochs and coast-line
decorate one side of nine of the seventeen boards, which have apertures on both sides for cartes
and cabinets. Two of these cartes are by the celebrated Aberdeen photographer George
Washington Wilson — the group of three men on the left-hand page and the father at top right

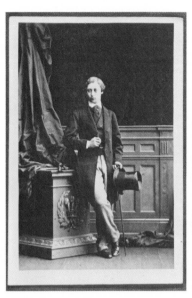

17a

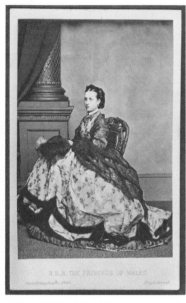

17b

17c

17d

17e

17f

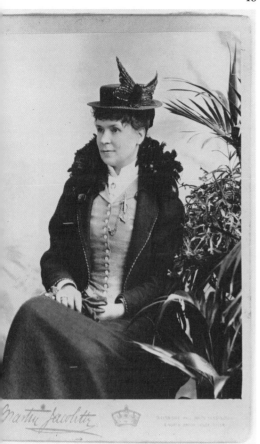

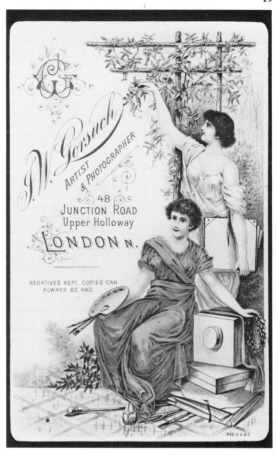

18 CABINET PRINT Studio Portrait by Martin Jacolette of South Kensington *c*1896, on P.O.P.
$4\frac{1}{4}'' \times 6\frac{1}{2}''$

19 REVERSE OF CABINET PHOTOGRAPH publicising the studio of J W Gorsuch *c*1890,
$4\frac{1}{4}'' \times 6\frac{1}{2}''$

17 CARTES-DE-VISITE *c*1859–72. Albumen prints. Carte dimensions $2\frac{1}{2}'' \times 4''$ ($3\frac{3}{4}''$)
 a HRH *Prince of Wales* by Camille Silvy *c*1859 (studio)
 b HRH *Princess of Wales* by London Stereoscopic & Photographic Company, 1863, at
 Sandringham
 c Portrait by O G Rejlander *c*1864 (Haverstock Hill, Hampstead, studio)
 d Reverse of carte featuring engraving of the premises of Appleton & Co of Bradford *c*1860.
 The photographer's glasshouse studio is clearly seen at the top of the building
 e Mother and son by William Notman of Canada *c*1866 (studio)
 f Welsh children by A Worthington of Aberystwyth *c*1872 (Gulls, sea and rocks are part of the
 studio decor)

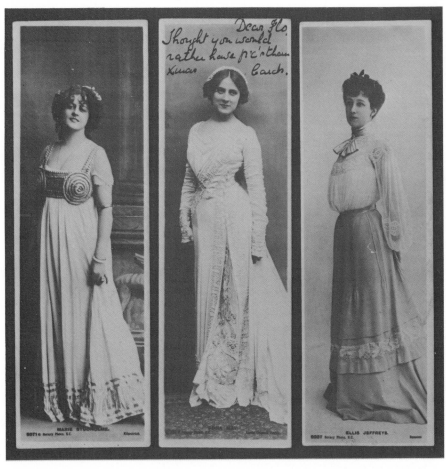

20 PANEL PRINTS of actresses Marie Studholme, Edna May, and Ellis Jeffreys, by Kilpatrick, Lizzie Caswall Smith, and Bassano (left to right) *c*1904, $1\frac{3}{4}'' \times 5\frac{1}{4}''$ bromide prints

21 COUPON PRINTS by H Wicks of Van Ralty studios (exclusive practitioners of coupon photography) *c*1912, $1\frac{1}{2}'' \times 3\frac{1}{2}''$

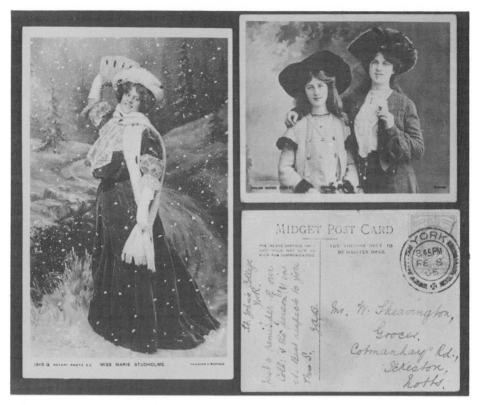

22 REAL PHOTOGRAPH POSTCARDS 1905. Standard size left: Miss Marie Studholme by Foulsham and Banfield, $3\frac{1}{4}'' \times 5\frac{1}{4}''$. Midget size right: Zena and Phyllis Dare by Bassano, $3\frac{1}{2}'' \times 2\frac{3}{4}''$ bromide prints

23 REAL PHOTOGRAPH CIGARETTE CARDS *Peeps Into Many Lands Series* c1907. Bromide prints $2'' \times 3''$. The cards are stereo pairs. A viewer—camerascope—could be obtained from the manufacturers on payment of 1/- post free

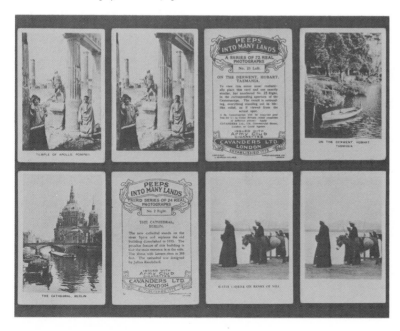

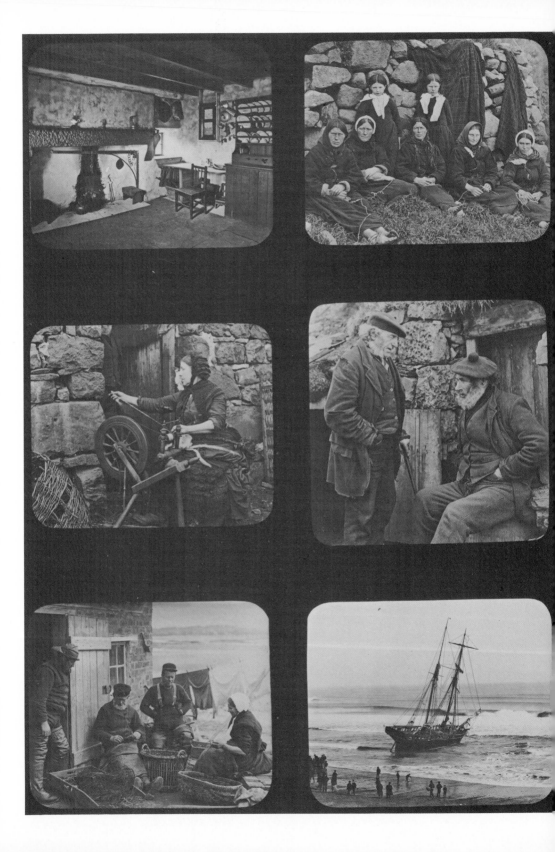

Lantern Slides

THE MAGIC lantern, which projected images painted on glass plates onto a white screen, had been popular for several years before photography was invented. As soon as photography on glass became possible (both the albumen and collodion processes were used for lantern slide making) photographic lantern slides made their appearance. (It is claimed that the Langenheim brothers of Philadelphia, USA were the first to produce albumen slides in 1849). At first produced in larger sizes, the majority of photographic lantern slides still available to the collector are $3\frac{1}{4}''$ square. They became a commercial proposition from about 1850 onward and were produced in vast numbers. They were sold in sets of travel sequences; narrative form illustrating popular stories and children's books; and as visual aids for many different purposes — from those which extolled the virtues of abstinence from alcohol, and series designed to accompany Bible reading sessions, to sets depicting different tribal customs and dress. Slide sets were produced in monochrome and in hand-coloured form. Slides made from around 1910–50 are on gelatine silver halide lantern plates or one of the contemporary colour processes. $3\frac{1}{4}''$ square remained the standard size until the popularity of 35mm projectors and 35mm colour transparencies ousted the larger size in the 1950s.

Photographic Ephemera

Photographs in Jewellery

IN BOTH Victorian and Edwardian times photographs were incorporated into jewellery. Daguerreotypes in gold, silver or pinchbeck type lockets, brooches, rings, bracelets are the most valuable and difficult to acquire. Ambrotypes, tintypes, albumen, and carbon prints associated with jewellery and other small items of ephemera such as pill and trinket boxes, pen and ink stands, and paperweights can still be found. The majority of these photographs are average to poor and are interesting for their association rather than in themselves. Occasionally an aesthetically pleasing image is seen. Photographs in buttons and tie-pins are usually more attractive, especially when delicately coloured by hand on the celluloid or ivorine bases favoured by Edwardian photographers.

24 LANTERN SLIDES of Scottish Highlands and Islands Communities by George Washington Wilson $c1872$. $3\frac{1}{4}'' \times 3\frac{1}{4}''$. From left to right and top to bottom:
Kitchen of Highland Cottage, *St. Kilda's, Group with Queen,*
Skye Crofter Spinning, *Octogenarian Crofters,*
Reddin' the Lines, *A Shipwreck on the Beach*

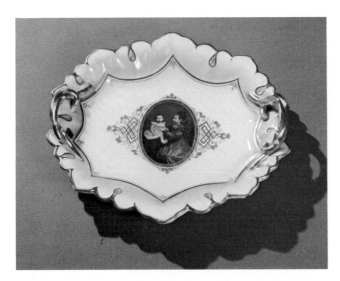

26 PORCELAIN DISH Karlsbad factory, mark A 42 *c*1862. Collodion photograph, in centre, of mother and child by unattributed photographer. Dish $9\frac{1}{2}'' \times 8''$

27 EDWARDIAN PERIOD PORTRAIT ON PORCELAIN PLAQUE by USA Studios, London *c*1908. Hand coloured. Plaque $3\frac{3}{4}'' \times 5''$ in dark green velvet and watered-silk-lined presentation case with gilt surround and leather covers

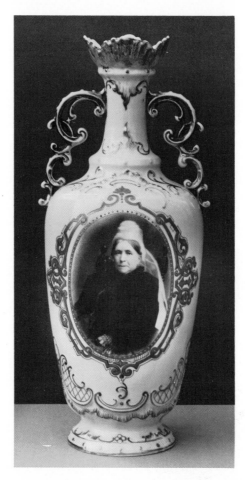

28 ONE OF A PAIR OF VICTORIAN PORCELAIN VASES English *c*1880. Photograph of Mrs Rimmer of Southport, Lancs, is in the form of a carbon transfer print $4\frac{1}{2}'' \times 6\frac{1}{2}''$. Photographer unattributed. The twin vase contains a photograph of Mr Rimmer

Photographs on Glass-ware and Porcelain

Between about 1856 and 1886 there was a demand for the transfer of photographs to glass-ware, porcelain plates, dishes, and vases. Certain firms established a reputation for these products. The earliest surviving examples are collodion prints. It was usual to strip a positive collodion photograph from its glass support and transfer it to the glass or porcelain article. If the receiving surface was porcelain the article was placed in a furnace for firing. The heat destroyed the collodion and burnt in the image formed by the silver, thereby making it permanent. In later examples carbon prints were used instead of collodions.

Photographic prints on domestic articles of porcelain are comparatively rare and should not be confused with photomechanical reproductions of photographs which have been transferred onto mugs, plates, dishes, and the like. The

latter are the products of Edwardian and later periods and are found in quantity in antique shops. A magnifying glass will reveal the regular pattern of the screen used in photomechanical reproduction. To see this clearly an eight or ten times magnification will be necessary.

Some charming Edwardian portrait photographs (carbon prints) were transferred to porcelain plaques, hand coloured and then fired. These are to be found in presentation cases lined with velvet or silk.

Photographs on Enamel

These images usually have a particularly lovely quality. Procedures were very similar to the production of photographs on porcelain. Lafon de Camarsac and Mathieu Deroche, both of Paris, specialised in this exacting craft, photographers sending their negatives to them for the making of carbon prints to transfer to the enamel plaques which proved so popular between 1880 and 1914. Both specialists signed the back of the plaques with their initials and the serial number of the photograph. The name of the photographer and date was often included. Particularly delightful was the photograph of Queen Alexandra by Walery, the back of the oval enamel being inscribed 'Walery, London, MD 29526'. The plaques were made for incorporation in jewellery or small display cases.

29 CARBON PRINT PHOTOGRAPHS ON ENAMEL PLAQUES by James Bacon and Sons of Leeds c1920. The large oval plaque is 2″ × 2½″. All are in sepia, and presented in velvet and silk-lined case as the photographer's specimen set

Crystoleum Photographs

Popular around 1885 to 1915, these were small convex curved glasses (circular, oval, rectangular, square) to which an albumen print was attached to the concave surface. The print was rendered transparent by waxing and was then coloured by the application of oil paint.

Suppliers kept unmounted photographs in stock and sold complete kits for the production of crystoleums. The range of photographs offered by one supplier appears to be based entirely on photographs of paintings by popular artists of the day such as Sir L Alma Tadema and Lord Leighton. Others offered photographs of famous actresses. It was usual to mount crystoleums in frames for wall display.

Photographs on Supports other than Paper

Photographs on Opal Glass

THIS SUPPORT for portrait photographs became very popular between 1865 and 1900 as an alternative to paper. The earlier examples were made by coating the finely ground side of the opal with collodio–chloride of silver and printing the image by placing the opal in contact with the negative plate. The image was then coated with copal varnish, which was deemed to render it permanent. Examples of these usually display a yellowed appearance and deterioration where the varnish has been scratched. The more satisfactory method was to coat the image with flux and fire the opal in a furnace so that as with porcelain the collodion was destroyed and the silver image burnt in permanently. Later examples were almost invariably carbon transfers; vignetting of the image was popular; and those opals produced by professional photographers of repute are very lovely indeed. Water-colour washes were applied to the back of some opals so that the images appear delicately coloured.

They were usually made for framing and display on tables, mantelshelves or walls and are usually $6\frac{1}{2}'' \times 8\frac{1}{2}''$ or larger. Unframed they are easy to identify, if framed they are recognisable by their white opalescent appearance. In many examples the photograph is signed and dated, and occasionally the name of the sitter is recorded.

Photographs on Cloth

Most of the existing photographs on linen, cotton, and silk were made from around 1870 to 1915. Cloth was sensitised and sold by the Platinotype Company to photographers so that photographs made on these fabrics were in permanent platinum. Individuals undoubtedly sensitised their own material but the problems attached to the attainment of even sensitisation must have deterred the majority.

Photographs on silk have a special appeal as the delicate texture and sheen of the material imparts a distinctive quality to the imagery which can be easily recognised in the original but is virtually impossible to reproduce. Printing on silk was used for portraiture, and for architectural and landscape subjects for clients or photographers themselves who wanted that quality unobtainable on

paper. It seems likely that cost and other factors limited production as surviving examples are by some of the best photographers of the period. This is recognisable even where there is no attribution.

An alternative method in use was the PRIMULINE PROCESS or DIAZOTYPE by which positive coloured prints of photographs could be obtained on fabrics. This process lent itself to the commercial rather than the artistic photograph.

Photographs on Birnham Wood Boards: Maucheline-ware
c1858–c1880
Photographs of scenic views and historic buildings were transferred to the wood surface that forms the substance of these wares which usually took the form of serviette rings, boxes and covers for books, photograph albums, and blotters. The varnish super coating protected the images from abrasion but did not prevent the mosaic type of cracking to which collodion is particularly prone.

30 PORTRAIT ON OPAL GLASS by J E Mayall of Brighton, 1879. The carbon transfer print is from a vignetted negative, the opal is $8'' \times 10''$ and inserted into a gilded wood frame with rich dark red velvet surround, the whole encased within an ebony picture frame ($12\frac{1}{2}'' \times 14\frac{1}{2}''$). The photograph was taken by Mayall himself, not one of his assistants.

Artistic Photo Co.

IMPERIAL MANSIONS, OXFORD ST., LONDON, W.C.

Stereo, Micro, and Panoramic Photographs

Stereoscopic Photographs

THE VAST NUMBER of stereo pair photographs which have survived is indicative of the popularity of this form of visual imagery. Most middle class drawing rooms contained a stereoscope at one time or another. Stereoscopes were made in many forms from simple table models to sophisticated self-standing ones, many of them in quality wood and with inlay or elaborate carving.

Stereo images (two photographs of the same subject, taken from slightly different angles but covering the same subject area, and mounted side by side) must be viewed so that the separate images fuse into one giving a visual impression of subject depth—three dimensions instead of two. They were produced as daguerreotypes, albumen prints on card, albumen prints on 'tissues' mounted into apertures so that they could be viewed by both reflected and transmitted light ('night' and 'day' scenes were the most effective), albumen and collodion transparencies on glass for viewing by transmitted light, and gelatino-chloride or bromide prints on card during the revival of interest at the end of the century.

The range of subjects was enormous and included: museum exhibits, views of popular places at home and abroad, narrative sequences, humour, ghosts, expeditions of geographical and archaeological interest. They were usually made and sold as sets. Series often turn up incomplete, but it is sometimes possible to track the missing numbers down. Some of the most outstanding photographers such as Claudet, Frith, Bedford, England, and Washington Wilson took stereoscopic photographs.

Microphotographs

J B Dancer of Manchester was responsible for developing the idea of microphotography and produced the first microphotographs proper in 1853. His pin-head-size photograph of a text of the Ten Commandments, containing 1,243 letters, attracted a great deal of attention. It was taken on a microscope slide for viewing in a powerful microscope. Sets of microphotographs in this form became very popular and a commercial enterprise.

Another form taken by microphotographs was their incorporation in fancy goods, such as ivory or bone penholders and miniature toy opera glasses, or jewellery, with a small magnifying or Stanhope lens set over the photograph.

Both forms are still available to collectors but they are becoming difficult to find.

31a PLATINOTYPE PRINT SET INTO GOLD AND PEARL LOCKET c1898. Photograph by Esme Collings
 b EDWARDIAN PORTRAIT PHOTOGRAPHS ON CELLULOID IN FORM OF BUTTONS c1906. Carbon print images are delicately colour tinted.
 c CARBON PRINT OF PORTRAIT PHOTOGRAPH IN FORM OF POSTAGE STAMP by the Artistic Photo Company c1875. Stamp size 7/10″ × 1″

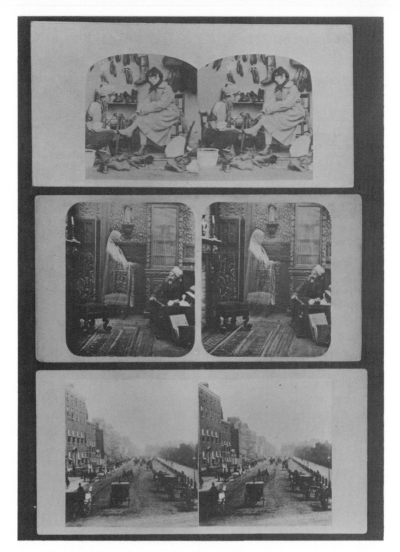

32 THREE STEREOPHOTOGRAPHS FOR REFLECTED LIGHT VIEWING,1864. From top:
 a One in a humorous narrative set, published by the London Stereoscopic Company
 b *A ghostly visitation to a Scrooge-like character* by M Laroche
 c *Princes Street, Edinburgh,* by George Washington Wilson. The prints are dated 1864 but
 the photographs could have been taken at an earlier date. Another view of Princes Street,
 Edinburgh, was photographed by Washington Wilson, in stereo, in 1857.
Cards measure $6\frac{3}{4}'' \times 3\frac{1}{4}''$, prints approx. $2\frac{3}{4}'' \times 3''$

33 STEREOPHOTOGRAPH SET *Ordnance Survey of Sinai,* 1869, published by the War Office.
The set, complete with viewer, is in a mahogany box. Toned albumen prints are paired onto
standard size card mounts. The photographs were taken by photographers of the Royal
Engineers. There are 36 pairs

34 THREE ITEMS OF PHOTOGRAPHIC EPHEMERA Souvenir pen and ink stand with albumen
print of Rialto Bridge, Venezia, inset. The item is a miniature.
 Ring box in dark blue velvet with chased silver top and portrait photograph on celluloid
inset, delicately colour tinted.
 Two paper-knives with pen-holders (combined) in ivory, with micro photographs set behind
Stanhope lenses in the knobs.

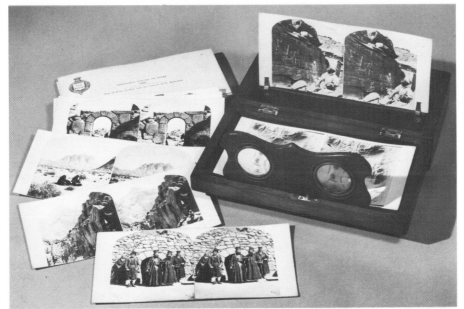

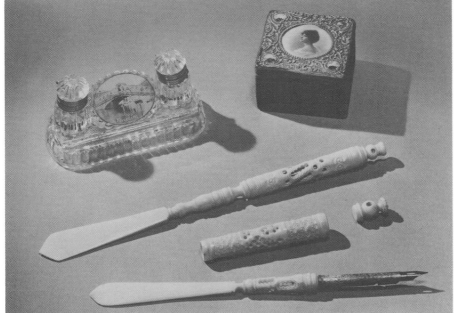

Panoramic Photographs

These were produced by two totally different methods. One was to take a series of photographs from a set viewpoint with a conventional camera rotated through a fixed angle from left to right, with edge overlap (each photograph with its neighbours), to permit matching up. The prints were mounted side by side. Although this method produced excellent documentation over a wide angle of scene there is little to appreciate from the aesthetic standpoint. The

other method involved the use of specially designed cameras: either the lens was designed to rotate from left to right in an arc and the back of the camera was curved, for example Kodak Panoram roll film camera, or the whole camera rotated on its axis while a governor-controlled motor wound the film past a slit from one spool to another. Such a camera can cover a complete circle of 360°. Cameras of this type were used for photographing extensive formal groups. The famous Sutton panoramic camera had a concentric and spherical water lens giving extensively wide angle coverage with which curved plates were used.

In the hands of an artist these panoramic camera views have decided aesthetic

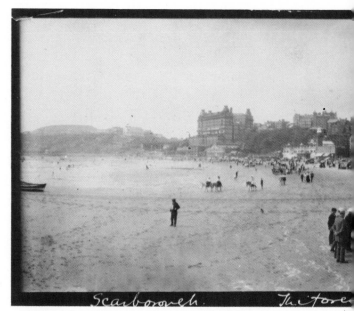

35 PANORAMIC PHOTOGRAPH probably taken with a Kodak Panoram roll film camera. *The Foreshore, Scarborough* by A H Robinson *c*1894, 12″ × 3½″ P.O.P. contact print

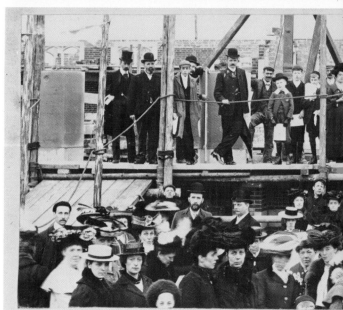

36 PANORAMIC PHOTOGRAPH of spectators at Foundation Ceremony, Ilkeston 1904, 12″ × 3½″ P.O.P. contact print, probably taken with a camera which rotated on its axis

appeal, especially when there are curves and receding lines in the landscape or townscape. For an example of the work of Joseph Sudek, who was a fine exponent of panoramic photography for many years, see p72. He used a large format view camera and a 1910 Kodak panoram camera on a tripod, whereas the majority of present day photographers use small hand cameras. He made contact prints only; his enlarger was last used in 1920. Contemporary only in the sense that he took photographs until his death in the mid 1970s. The style of this elderly man with one arm is timeless and defies classification.

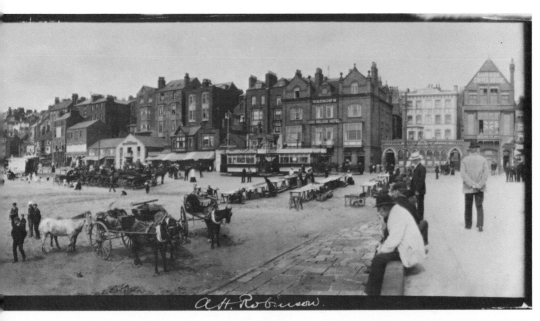

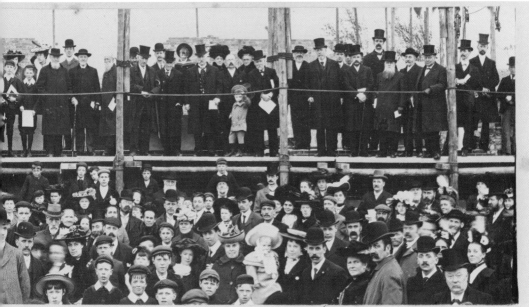

Illustrated Books, Topographic and Travel Albums, Family Albums

ALBUMEN PRINTS were used for book illustration from about 1852 to 1870, for example:

Ruined Abbeys and Castles of Great Britain and Ireland by William Howitt with photographs by Sedgfield, Ogle, and others, 1864

Our English Lakes, Mountains and Waterfalls as seen by William Wordsworth with 12 photographs by Thomas Ogle, 1864

The Lady of the Lake by Sir Walter Scott with 9 photographs, 1869

Scenic views, architectural and archaeological photographs were assembled with suitable text (frequently the work of one photographer) for publication in the form of albums or portfolios, for example:

The Crimean War by Roger Fenton, 1855

Egypt and Palestine by Francis Frith, 1857

The Crystal Palace at Sydenham by Philip H Delamotte, 1859

Photographic Views of Sherman's Campaign by George N Barnard, 1866

Photographs of Scottish Scenery — Glasgow by Thomas Annan, 1867.

Many travellers bought individual albumen prints from printsellers and pasted them into their own travel albums. These included photographs of India, China, Japan as well as Europe and America.

Family Albums were as popular in the nineteenth as in the twentieth century, especially in households which boasted a keen amateur photographer. These albums are particularly fascinating and give an insight into Victorian domesticity, customs, and entertainment.

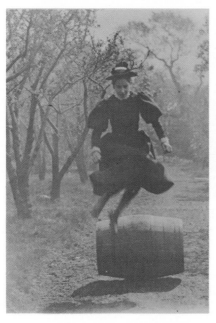

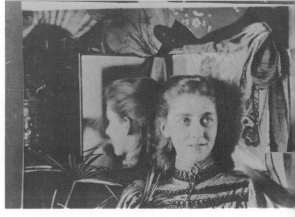

37 PHOTOGRAPHS FROM THE DRIFFIELD FAMILY ALBUM 1890–5
a *May Driffield jumping over a barrel* by her father, Vero Charles Driffield, 1892, $3\frac{1}{4}'' \times 4\frac{3}{4}''$ bromide print
b *Portrait of May* by her father, c1894, $4\frac{3}{4}'' \times 3\frac{1}{4}''$ bromide prin
The investigations of V C Driffield and Ferdinand Hurter in the way light acts on the sensitive plate formed the basis of most later evaluation of exposure–density characteristics of the photographic process. They were jointly awarded the Progres Medal of the RPS in 1898. By courtesy of Philip R Evans

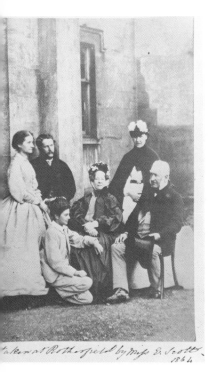

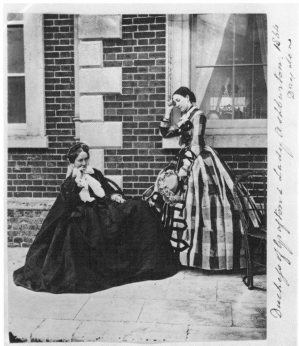

38b

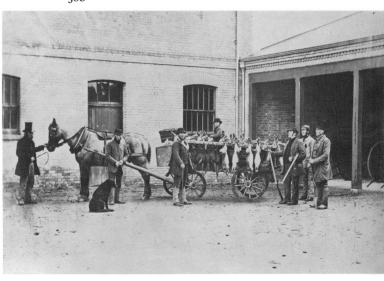

38d

38 PHOTOGRAPHS FROM THE WILSON FAMILY ALBUM 1864
 a *Group, including Henry Wilson and Mrs H Wilson* (centre) taken at Rotherfield by Miss E Scott, 1864, $3\frac{1}{2}'' \times 5''$
 b *The Duchess of Grafton and Lady Ashburton at Stowlangtoft*, by Dryden, 1864, $3\frac{1}{2}'' \times 4\frac{1}{4}''$
 c *Edward Savage, aged ?, at Stowlangtoft* by Dryden, 1864, $2\frac{1}{4}'' \times 3\frac{1}{2}''$
 d *Outdoor staff with horse and game cart,* unattributed *c*1865, $9'' \times 6\frac{1}{2}''$

43

Permanent Photographs

A MAJOR PROBLEM of nineteenth-century photographers was the instability of the photographic print. Many old photographs have deteriorated to such an extent that the image is barely discernible, having faded from rich sepia or red-brown to pale sulphur yellow. This is particularly noticeable in cartes-de-visite and book illustrations.

The search for a permanent form of print led to bichromated colloid printing (chromic salts, pigment, and gelatine, gum or similar vehicle). The image was obtained by hardening to light *not* darkening, as is the case with all silver salt printing processes. There were many variants, the most important being carbon printing and woodburytype.

39 WOODBURYTYPE *Anthony Trollope* by Lock and Whitfield *c*1877, $3\frac{1}{2}'' \times 4\frac{1}{2}''$. One of 35 Woodburytypes which illustrate *Men of Mark, Gallery of Contemporary Portraits,* third series, published in 1878

Carbon Prints 1864–c1936

They can be recognised by their richness, tonal gradation, image colour (carbon tissues were made in black, brown, sepia, red chalk, and a range of blues and greens), and a slight relief when the print is viewed at an angle. Carbon printing was practised by professional photographers in particular, and was used for book illustration (c1870–c1886), and for quality photographs from exhibition prints to cartes-de-visite and cabinets. As it was a transfer process (the negative was printed on carbon tissue and the positive image transferred during development to a support) most of the photographic images on opals, wood, ceramics and enamel-ware between 1870 and 1914 are carbon prints. The process was extended in the twentieth century to colour photography. Three of the biggest producers of carbon tissue were: T & R Annan of Glasgow, Elliot and Son of Barnet, and the Autotype Printing and Publishing Company of London.

Woodburytypes c1868– c1900

Woodburytypes are semi-photomechanical prints bearing a close resemblance to carbon prints having been developed from the same principle. The process produced true continuous half tones and was one of the loveliest forms of reproduction invented. The gelatine relief from which the lead moulds for print making were made gave sharp edge definition to the image, so that tones are well defined and separated, giving remarkable image clarity. The relief effect is easily seen in woodburytypes, the prints ranging from warm sepia to purplish brown. It was an improved and cheaper form of printing for book illustration at the time, around 1875 to 1900, although each print had to be manually mounted onto the page. The Stannotype was a modification of the process. Woodburytypes are sometimes found on opals and transparencies as well as on paper.

Gum Bichromate Prints (Photo-Aquatints) 1895 to the present

In their most delicate form they are comparable to monochromatic water colour paintings and pencil sketches. Essentially the process is a method of producing prints in bichromated gum without transfer: drawing paper is coated with a mixture of gum, chromic salts, and a pigment, and exposed to a negative when dry. It is possible to subdue photographic detail, and change tonal relationships during development of the image by successive coatings. Colour prints are made by using different coloured pigments in successive coatings. The process is practised almost exclusively by amateur photographers. Prints are recognisable by the granularity of the image. There are a few outstanding practitioners of the process today. OIL PIGMENT PRINTS (1904–c1938) are similar to gum bichromate prints but are usually coarser in textural effect and stronger in tone, some being comparable to charcoal drawings. A bichromated gelatine positive relief image on paper was made from the negative and made clearly visible by the application of oil pigment or fatty ink with a brush. Skilled artistic judgement and manual dexterity could effect remarkable control, and a range of different prints could be made from one negative. Even greater control was obtained by transfer. A modification—BROMOIL PRINTING—permitted change of image size which was considered an advantage.

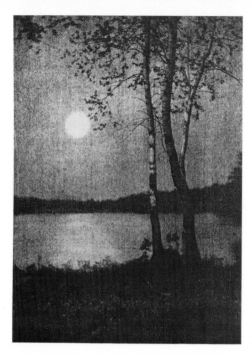

40 GUM BICHROMATE PRINT *Night* by Harold Leighton *c*1929. A pictorial photograph, $4\frac{1}{4}'' \times 6''$

Photogravure Prints *c*1883–*c*1920

Photogravure prints of this period were described by the inventor of the process (Karl Klíc of Vienna) as 'deep copperplate engravings by photo-chemical methods'. Modifications and improvements later established the process as being the best for photomechanical reproduction of photographs. During the early years photographers exercised a considerable degree of control over plate and print making. They regarded the process as being capable of the production of 'original prints', and signed them. Photogravures were exhibited alongside photographic prints in exhibitions and were used for quality book illustration. Amongst the classics are: *Sun Artists*, a quarterly published in Britain in eight issues between October 1889 and July 1891, each issue illustrated with photographs by celebrated photographers of the day, including Sutcliffe, Robinson, and Evans; '*Camera Work*', published in fifty issues (1903–17) in USA by Alfred Stieglitz for the Photo-Secession (see p69), and including the work of photographers of international repute, such as Steichen, Coburn, Demachy, Kuhn, and Clarence White.

42 PLATINUM PRINT ON SILK *Temple of Amun, Karnak* by unattributed German photographer *c*1882. Negative probably made 1865–75. Print size 14″ × 10″. It is not possible to convey the rich tonal quality or surface texture of the silk print in the reproduction. These subjects (monuments and archaeological sites in the Near East) were popular with nineteenth-century photographers, either officially attached to archaeological expeditions, or as individuals with publication in mind. The best known are Maxime du Camp (1849–52); Francis Frith (1856–9); Francis Bedford (1862–3); James Robertson and his assistant Felice Beato (1853–6); Bonfils (*c*1854–8); Louis de Clercq (1859–60;); Felix Teynard (*c*1852)

41 HAND PHOTOGRAVURE PRINT *Lago Lecco* by J Dudley Johnston *c*1905, $7'' \times 5\frac{1}{4}''$. He was a member of the Linked Ring and became President of the Royal Photographic Society for two separate terms of office. He was also the Society's Honorary Curator and was responsible for the formation and development of one of the finest collections of photographs and equipment in Britain

42

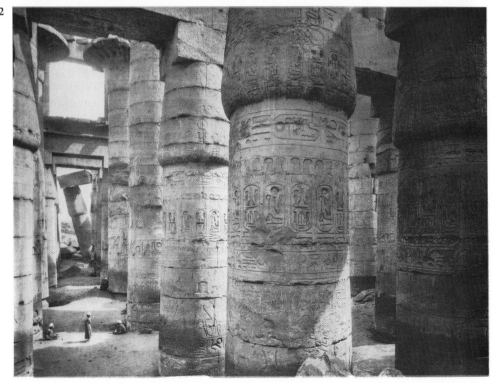

Platinum Prints (Platinotype) *c*1880–*c*1915

Platinum prints are unequalled for rendition of subtle tonal qualities in the image. Characteristic is the remarkable delicacy and separation of tones throughout (no opaque blacks or blank whites), the image colour (clear greys or rich warm brown), and complete freedom from reflections as the surface of the print is matt. The quality and depth of image of a platinum print is due to the impregnation of the paper with sensitised platinum salts (it was *not* a surface coating). It has the advantage of being more stable and less susceptible to fading and staining than silver processes. Provided processing was carried through punctiliously, platinum prints are permanent. Textile fabrics were used for printing as well as paper. The Platinotype Company was the chief supplier, although some photographers prepared their own paper.

The Platinotype Process was very popular with many of the most eminent photographers of the period, both professional and amateur, including Emerson, Evans, Horsley Hinton, Walter Barnett, Walery and Sutcliffe in Britain; Clarence White, F. Holland Day, and Gertrude Kasebier in North America.

Modern Processes

Gelatino-Bromide Prints and Negative Materials *c*1880 to the present

THESE BELONG to the twentieth century. The basic processes, with modifications and improvements, are essentially the same now as when they were first used. A fundamental difference between bromide prints and earlier printing processes is that their speed makes them suitable for projection printing, thus negatives could be smaller than was practical in previous times. Basically prints are black and white although variants in emulsions (chloro-bromide papers) produced a range of brown tones, and sepia can be obtained by toning. Ivory and cream papers, as well as surfaces ranging from matt to extra rough, introduced variety. Dyes incorporated into negative emulsions produced colour response approximating to the way the human eye sees colour. As a result bromide emulsions record reds as greys not black, and blues as greys not white. At last photographers were able to record blue sky and clouds on the same negative as the landscape (most prints from collodion negatives have blank white skies).

The greatly increased speed of the bromide process encouraged photographers to take subjects never before attempted: casual groups, real action, subjects of all kinds in motion, and spontaneous expression. It was now possible to hold a moment of time in suspense for ever. However, traditional subjects photographed in the orthodox manner accounted for a large proportion of professional photography.

44 EARLY PRESS PHOTOGRAPH *Fire-Engine and Firemen at Scene of Fire* published by Sussex Daily News *c*1890. $9\frac{1}{2}'' \times 6\frac{1}{2}''$ bromide print on fancy card mount

43 EARLY EXAMPLE OF INSTANTANEOUS PHOTOGRAPHY ON BROMIDE NEGATIVE EMULSIONS. *Cockspur Street and Trafalgar Square* by the London Stereoscopic Company, *c*1886. Albumen print 11″×7½″

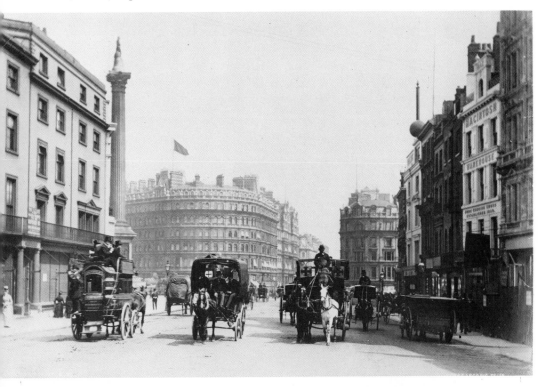

44

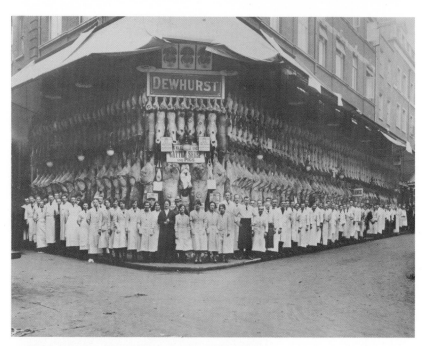

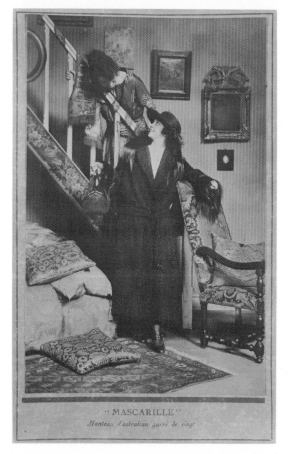

"MASCARILLE"
Manteau d'astrakan garni de singe

45 EARLY COMMERCIAL PHOTOGRAP[...]
Dewhurst, Butchers and Employees, by H
Wicks for Bassano, 1923. The notice in th[e]
centre informs that the carcases were onc[e]
'His Majesty the King's Cattle, Sheep and
Pigs'. The smaller notices to the side, afte[r]
stating the date with the Royal crest in th[e]
centre, inform us that the said cattle, shee[p]
and pigs were 'Fed by His Majesty, the
King'. Bromide print $11\frac{1}{4}'' \times 9''$

46 EARLY FASHION PHOTOGRAPH
'Mascarille' manteau d'astrakan garni de sing[e]
by Jungmann of Paris, c1919. $4\frac{1}{2}'' \times 6\frac{1}{2}''$
bromide print on fancy buff coloured
mount

47 DAVID OCTAVIUS HILL AND
ROBERT ADAMSON *Alexander Handisyd[e]
Ritchie and William Henning, sculptors*
c1844. Reproduced from hand
photogravure print made by James Craig[?]
Annan c1890 from the original calotype
negative, $6\frac{1}{2}'' \times 8\frac{1}{2}''$. The image is laterally
reversed when compared with the origin[al]
salted paper print

Distinguished Photographers and Fine Photographs

PHOTOGRAPHIC IMAGERY is influenced by social demand and artistic convention. For many historians its immense value as a documentary medium outweighs all other considerations. Old photographs play an important role in documentation of architecture, in the study of industrial archaeology, in town and country planning, and in dating and relating periods of fashion and dress from Victorian times onward. Photographs have brought about social change and slum clearance: for example, Jacob Riis's photographs of the New York slums and their inmates in the last decade of the nineteenth century; and Lewis Hine's photographs of children labouring in factories and mines at the beginning of the twentieth century were used as evidence in the passing of the Child Labour prevention laws in the USA.

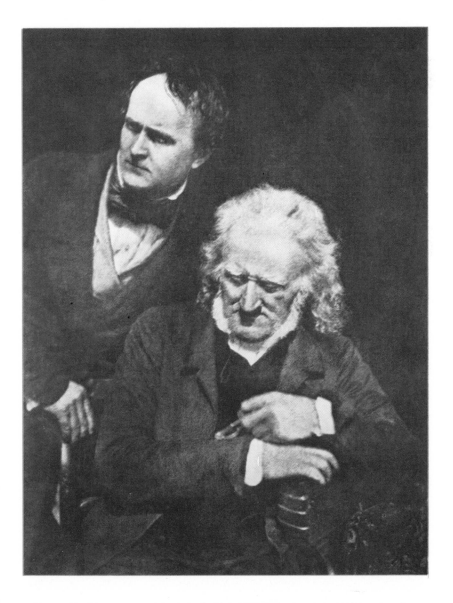

Although photography is essentially a recording medium the photographer can impose his own individual way of seeing by effectively controlling the imagery. He has power to select and reject, to organise picture elements into an arrangement he finds satisfying, to convey mood and evoke response in the viewer. He can capture a moment of time in visual terms, thereby making it timeless. By these means a photographer determines his own style, and makes his work recognisable without reference to his signature.

David Octavius Hill and Robert Adamson of Edinburgh, partners in photographic portraiture, 1843–7

Hill was a landscape painter and the secretary of the Royal Scottish Academy. The partnership was established to make calotype *aides-mémoire* of those who attended the First Free Church Assembly of Scotland in 1843 so he could produce a commemorative painting. It is said that Hill was responsible for the artistic direction and Adamson for the technical production. The results were so successful that people unconnected with the Church Assembly came to their premises on Calton Hill for sittings.

Their photographs are recognisable by the superb picture construction and interpretation of their sitters' characteristics, based on adherence to traditional artistic conventions in portrait painting but sometimes employing a less formal approach. Sitters were photographed in sunlight outside the studio, and lighting, chiaroscuro in effect, was used faultlessly to reveal or subdue features and to emphasise pictorial design. Skilful use of space established relationships between near and distant objects, and conveyed depth and height as well as size.

A revival of interest in their work led to the making of carbon prints from the original calotypes in the eighteen sixties and photogravure prints at the end of the century by Thomas Annan and his son, James Craig Annan. In 1916 Jessie Bertram made a further set of carbon prints from original calotypes.

Roger Fenton, photographer c1847–62

This outstanding Victorian photographer took many of the most significant and finest photographs of the nineteenth century in a brief period of twelve years. He was a barrister who had studied painting under Delaroche but took up calotypy initially as an amateur. He practised photography professionally between 1852 when he visited Russia (commissioned by Vignoles to photograph his bridge over the Dnieper at Kiev) and 1862, when he returned to the practice of law. He was a founder member and the first Honorary Secretary of the Association that became the Royal Photographic Society. He can be regarded as one of the first Court photographers—he took many delightfully informal photographs of the Royal family and their retainers as well as more formal portraits, and was the official photographer to the British Museum between 1854 and 1859. His still life studies are very impressive.

Fenton is probably best known as one of the first war photographers. He went to the Crimea in March 1855 under Royal Patronage and commissioned by the printsellers Thomas Agnew and Sons. He returned in June of the same year having taken 360 photographs under appalling conditions. The photographs were made up into albums, now highly prized by collectors.

Undoubtedly his finest work is documentary in character and intent. He photographed cathedrals, ancient monuments, and landscapes, many of which were published in the form of portfolios and albums by Francis Frith and Thomas Agnew. His skill is remarkable in the positioning of people in his photographs to add interest and to give scale. This ability can be seen in his studies of groups of officers and men taken in the Crimea who look relaxed and at ease, and is the factor by which his work can be distinguished from that of his contemporaries.

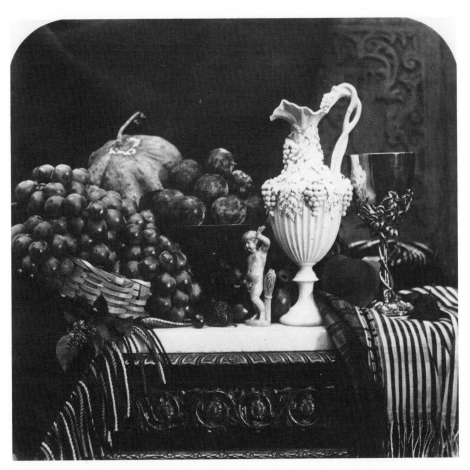

48 ROGER FENTON *Still Life* 1854. One of a set of photographs of fruit, porcelain, and silver objects with variations in composition. Albumen print 16″ × 15″. *In the collection of the Royal Photographic Society*

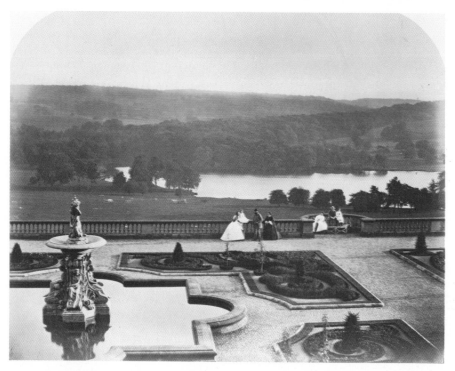

49 ROGER FENTON *Terrace and Park of Harewood House* 1861. Albumen print 20″ × 16″. *In the collection of the Royal Photographic Society*

James Mudd, topographical and industrial photographer, 1854–*c*1893

An amateur photographer before 1854, Mudd made waxed paper negatives of his landscape and architectural subjects. He was one of the first photographers to use dry collodion plates (1856) as an alternative to the more popular and widely used wet collodion plates. He took photographs for Beyer and Peacock, manufacturers of steam engines, and visually documented streets and houses in the old parts of Manchester prior to their demolition. He was one of the leading photographers in the North West of England in Victorian times. The heavy industrialisation of the area in those days was well recorded by Mudd and his contemporaries: their photographs—housed in the Manchester Central Library and the Manchester Science Museum—are of considerable interest to industrial archaeologists today.

Francis Frith of Reigate, photographer, printer, publisher, 1855–93

Frith is probably the best known of a select group of photographers who controlled the entire process of production through to mass distribution. Others of this group were: James Valentine of Dundee, George Washington Wilson of Aberdeen, and at a later date William J Day of Bournemouth, Fred Judge, and Arthur Dixon. The firms established by these photographers became the largest producers of picture postcards in this century in Britain.

Frith travelled Britain, Europe, Egypt, Syria, Nubia, Palestine, India, China,

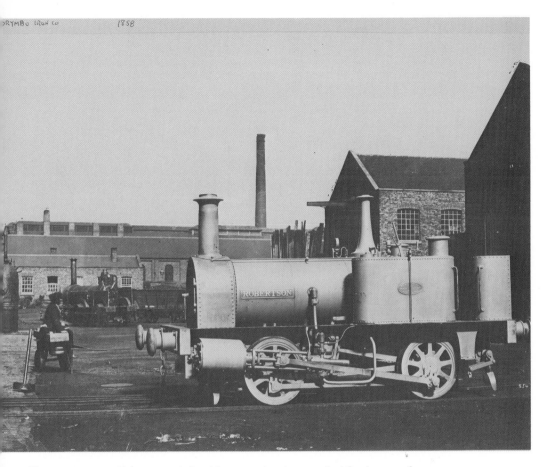

50 JAMES MUDD *Robertson, an industrial steam engine* photographed for the manufacturers Beyer and Peacock, 1858. (A very early example of an industrial photograph of particular interest to industrial archaeologists. The engine was made for the Broughton Coal Company, Lancashire.) Mudd made the negative on a dry collodion plate, 15″ × 12″ and took an albumen print from it. *By courtesy of Harry Milligan FRPS*

and Japan taking photographs for publication in portfolios, albums, and as loose prints. His own photographs were usually issued under the stamp 'Frith's Series', those taken by the photographers whom he employed were stamped: 'Francis Frith and Company' or 'F.F. and Co'. Amongst photographers whom he engaged were Francis Bedford, James Mudd, and Frank Meadow Sutcliffe — all eminent in their own right. In this context it is virtually impossible to attribute the work. Mathew Brady of New York and Washington likewise employed at least twenty-five photographers who worked for him anonymously in his portrait studios and documented the American Civil War (Gardner and O'Sullivan amongst them). Only a skilled specialist can identify Brady's own work from the rest. This anonymity was and still is the usual practice amongst professional photographers, making authentic attribution in respect of professional photography a difficult task, unless a distinctive style has been developed.

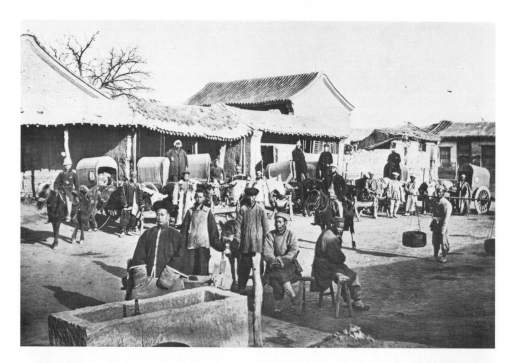

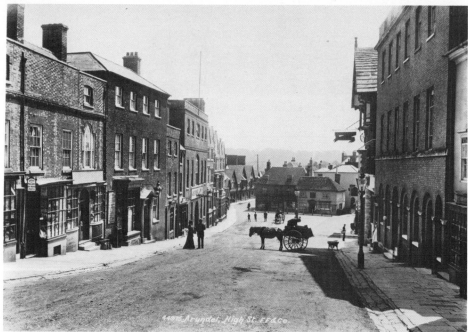

51 FRANCIS FRITH *Inn Yard, Pekin* 1869, $6\frac{1}{2}'' \times 4\frac{3}{4}''$. One in Francis Frith's own series taken on a visit to the Far East (China and Japan). At first glance this appears to be a casual grouping but a careful examination reveals that the individuals have been skilfully posed to appear natural. (A time exposure of several seconds would have been required as Frith would have used a collodion plate for the negative)

52 FRANCIS FRITH AND COMPANY *Arundel High Street, Sussex* 1900. Albumen print $8'' \times 5\frac{1}{2}''$. The photograph was taken by one of the company photographers two years after Francis Frith's death

Traveller Photographers

DEMAND for information about places and the people who inhabited different regions activated the greatest use of photography in the nineteenth century. The following British traveller photographers produced superb photographs:

Francis Bedford accompanied the Prince of Wales on a tour of the Middle East in 1862. His cathedral and church interiors are particularly praiseworthy, and his outdoor scenes reveal a remarkable degree of sensitivity in interpretation.

Samuel Bourne, setting up in partnership in India with Shepherd, travelled Kashmir and the Himalaya regions taking fine photographs under extremely hazardous conditions (1863–6).

William England was chief photographer to the London Stereoscopic Company. During the eighteen fifties he took hundreds of photographs for stereoscopic viewing. He was so successful that he became financially independent in 1863 and thereafter specialised in Alpine views for his own pleasure.

Robert MacPherson, an Edinburgh surgeon, became the leading photographer of architecture, antiquities, and sites in Rome where he was resident in the eighteen fifties and sixties.

53 SAMUEL BOURNE *Kashmir Landscape c*1864. Albumen print 12″ × 10″ in album containing photographs of India, by Bourne *In the collection of Norman Hall*

James Robertson was chief engraver to the Imperial Mint, Constantinople. He took photographs in the Cimea, following Fenton in 1855, and photographed extensively in Europe and the Middle and Far East. *Felice A Beato* was his assitant for a time and likewise a fine photographer.

European photographers whose work was internationally recognised:
Eduard Baldus, Maxime du Camp, Charles Marville, Bisson Frères, Gustav Le Gray, Henri Le Secq, Charles Nègre of France; Adolphe Braun (Alsace), Krone and Locherer of Germany; Felice A Beato, Alinari brothers, Carlo Ponti and Sommer (Napoli) of Italy.

In **USA** William H Jackson photographed the building and progress of the railroad from East to West, and was appointed photographer to the Hayden survey of the Yellowstone Region (later to become a National Park and Nature Reserve) in the 1870s. Carleton E Watkins and Timothy O'Sullivan were also fine photographers of the environment in the 1860s and 70s.

54 CHARLES DODGSON (LEWIS CARROLL) *The Rossetti Family* 1863. Christina is on the left of the group and Dante Gabriel plays chess with Mrs Rossetti. Reproduced from a copy negative by Alvin Langdon Coburn. *In the collection of John Hillelson*

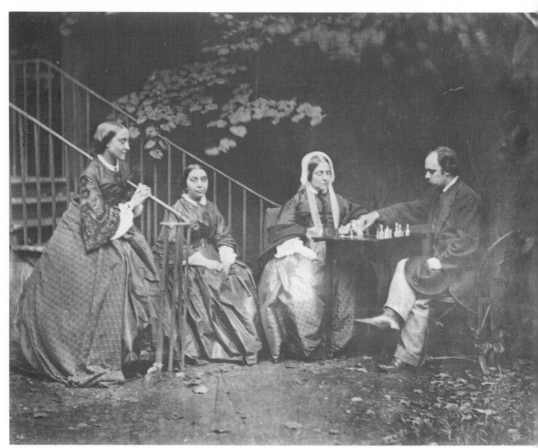

Pre-Raphaelite Influence

IT IS ONLY to be expected that gifted amateur photographers who were connected with art circles were influenced by current ideas of subject presentation and picture construction. This influence is clearly seen in the work of Lady Hawarden, Julia Margaret Cameron, Lord Somers, and Lewis Carroll.

Lewis Carroll (Rev. Charles Dodgson)

Carroll was an enthusiastic amateur portrait photographer between 1856–80, whose sitters were principally fellow dons, clerics, and little girls. There is a curious mixture of phantasy and reality in his visual imagery which relates to some of his writings. The lighting used is low frontal and the depth in the subject is compressed in the image; the emphasis is on linear design rather than form. His photographs are eagerly sought by collectors.

Julia Margaret Cameron

Julia Margaret Cameron was an enthusiastic and very gifted amateur portrait photographer between 1864–78. Unconventional in life as in her approach to photography, she worked within certain artistic restraints (G F Watts, the painter, was her adviser and admirer) and carefully monitored the lighting effects in her 'studio', a converted glazed fowl house. Her best work—close up

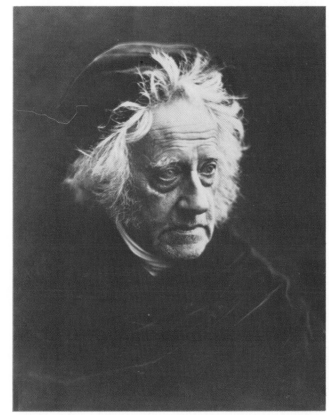

55 JULIA MARGARET CAMERON *Sir John Herschel* 1867. Inscribed beneath the image. 'From Life taken at his own residence Collingwood April 1867' in the photographer's hand writing and signed by her. Albumen print 12″ × 15″. *Formerly in the collection of Norman Hall*

59

56 JULIA MARGARET CAMERON *The whisper of the Muse* (G F Watts, the painter, and his children) *c*1867. Reproduced from a copy negative made by Alvin Langdon Coburn. *In the collection of John Hillelson*

studies of eminent men of the day, beautiful women, and delightfully sympathetic child studies—shows remarkable human response from her sitters who, after lengthy posing sessions, had to endure exposure times from twenty seconds to three minutes, in most cases without any support to back or head. The slight blurring of the features, where it occurs in images, gives a becoming roundness and softness to the portrayal. Working entirely visually and by instinct she was one of the first photographers to employ selective focusing which also adds roundness to form and creates an impression of depth. Many of her narrative studies are over-sentimentalised and exhibit weak picture construction. Her lack of technical skill is revealed in blemishes, spots, streak marks from uneven coating of the plates, and faded albumen prints. Close viewing is undesirable: the picture components integrate into an impressive whole when seen at a distance. Colnaghi's produced quality albumen and carbon prints from her negatives and sold them for her. The darling of the auction houses, her photographs commanded the highest prices of any Victorian photographer for a number of years.

Photographs by Fenton, MacPherson, Emerson and others are also within the top price bracket at the present time.

Narrative Illustration and Genre Studies 1856–c1886

IN THE EARLIEST attempts to use photography as a medium for artistic expression photographers emulated subjects, styles, and approaches which were within the established conventions of contemporary and classical painting. Royal patronage was an encouragement.

Henry Peach Robinson

The most distinguished of this company, Robinson was a professional portrait photographer from 1855 to about 1888, and was commissioned by Prince Albert to produce a composite photograph annually, based on a romantic or noble theme.

Robinson produced his composite photographs by combination printing, that is he photographed the subjects of his compositions either singly or in groups against the appropriate background, and printed the several negatives, one at a time, onto the printing paper, having blacked out with varnish or paper those parts of each negative which were not wanted. It was a complicated process requiring great skill and ingenuity as well as a thorough understanding of perspective and size relationships. For his genre studies he introduced a degree of artificiality by employing fashionable young women who could pose elegantly as models for pictures supposedly taken of farm girls in the country, or fisherfolk at the seaside. His composites were based on ideas developed from poetry, prose (*Sleep, Fading Away, The Lady of Shalott*), from popular legendary pastimes (*Bringing Home the May*), or romantic notions of rural life (*When the Day's Work is Done, Dawn and Sunset, He Never Told His Love*). He lectured extensively and was the author of several books, including *Pictorial Effect in Photography*.

Other photographers, commanding respect, who produced narrative and genre studies were William Lake Price, Oscar G Rejlander, and Julia Margaret Cameron. The efforts of lesser photographers appear pathetic and banal.

57 MACLOSE MACDONALD AND COMPANY *Members of European Royal Families* c1889. This composite is a photomontage of photographs taken in different places but suggests a family group taken in one place at one time. Featured are the King and Queen of Denmark, the Princess of Wales and the Czarina of Russia, the Czar of Russia and the Prince of Wales, Commercially successful, composites of members of the Royal Family were produced in large quantities during the latter part of the century

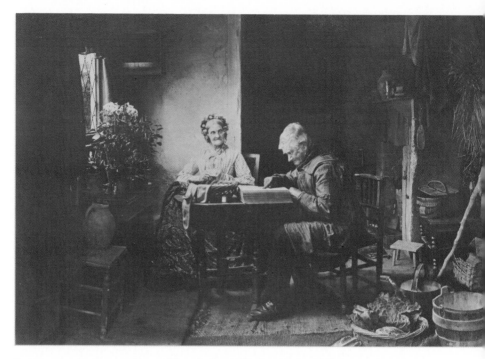

58 HENRY PEACH ROBINSON *When the Day's Work is Done* 1877. A composite by combintion printing. Carbon print 20" × 14". The old man was a crossing sweeper. When Robinson saw him he visualised this picture and invited him to his studio for the sitting. He then had to find an old lady to match—the two old folk never met each other. The background was one of Robinson's favourites: by repositioning the set and the objects he achieved several variations for a number of different composites of which *Dawn and Sunset* and a *Cottage Home* are two. *In the collection of the Royal Photographic Society*

59 HENRY PEACH ROBINSON *Shrimpers* 1887. An ingenious composite made by combining at least five negatives at the printing stage. Platinum print 20" × 11". Although the comparatively fast gelatino-bromide emulsions were available by this date so that a single negative could have satisfactorily recorded the totality of the scene, Robinson preferred several negatives and combination printing. *In the collection of the Royal Photographic Society*

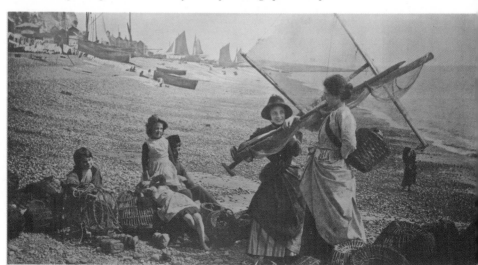

Social Documentary Photography 1860–c1886

F R O M T H E 1860s onwards the value of photography as a means of documenting social conditions came to be appreciated. For example, children in Dr Barnardo's Homes were photographed soon after arrival and again after they had been properly clothed and fed. Criminals were photographed and visual records filed.

Thomas Annan
A Glaswegian, he was commissioned by the City of Glasgow Improvement Trust to photograph the Closes district—a condemned area of the slums. The photographs, in the form of carbon and photogravure prints, illustrated publications such as *The Old Closes and Streets of Glasgow*. These limited editions are now eagerly sought by collectors.

John Thomson FRGS
Thomson was photographer to the Royal Geographical Society and travelled in India and the Far East photographing local people going about their daily business. Between 1877–8 *Street Life in London* was published in twelve separate issues for 1/- a copy. Woodburytype prints illustrating the text were made from Thomson's photographs. He and Adolphe Smith wrote the text. The publication is probably the earliest example of journalist and photographer working together and gives a fascinating insight into the street trades and outdoor pursuits long since vanished from the London scene.

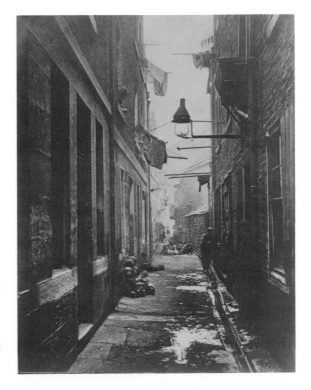

60 THOMAS ANNAN *A Close in the Saltmarket district of Glasgow* 1868. One in a series of photographs taken for the City of Glasgow Improvement Trust by Annan before the condemned slum area was demolished. *By courtesy of John Craig Annan.*

63

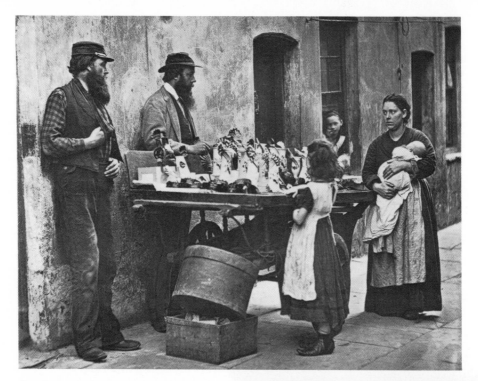

61 JOHN THOMSON FRGS *Dealer in Fancy Ware* c1875. One of thirty six photographs printed as woodburytypes $(4\frac{1}{2}'' \times 3\frac{1}{2}'')$ and published as *Street Life in London*.

In this text the dealer (a 'swag') is quoted as saying '... women will have ornaments ... I have known them swop their underclothing for a comb when their toes was sticking through their boots'. *In the collection of Norman Hall*

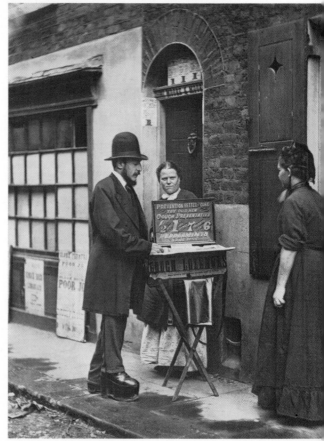

62 JOHN THOMSON FRGS *Street Doctors* c1875. Another of the street photographs from *Street Life in London*. The text informs that street vendors of pills, potions and nostrums use what may be called 'crocus latin', and scare people into buying their wares. *In the collection of Norman Hall*

64

Edward S. Curtis

One of the most penetrating social documentary interpretations of people ever made were the photographs—over 40,000—that Curtis took from 1896 to 1930 of the Red Indian tribes of North America. The published work *The North American Indian* consists of twenty volumes of text, each accompanied by a portfolio of photogravure prints of his photographs. Individual prints are available to collectors.

63 EDWARD S CURTIS *Nine Pipes Flathead* 1910. Photogravure print in warm sepia, 5″ × 7″

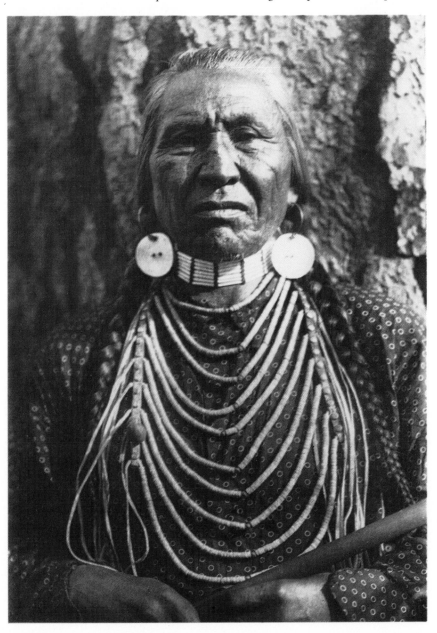

Dr Peter Henry Emerson

IN CONTRADICTION to the established concepts of artistic photography, based on elaborately contrived situations and the employment of models, a return to Nature was advocated with eloquent and fiery passion by Emerson, a naturalist and amateur photographer from 1882 to about 1933, who photographed real people in real life in real landscape. His favourite subjects were the Fenlands and the peasants and fisherfolk of East Anglia. The great significance of Emerson and his concepts was that he set the scene for the emergence of photography as an art medium in its own right, freed from the conventions of painting. He wrote and lectured on the necessity to understand the medium and urged photographers to work within its limitations and make use of its advantages. He also promoted platinum and photogravure printing. He presented his work in portfolios and albums published in limited editions which included *Life and Landscape on the Norfolk Broads* (joint author with T F Goodall, the painter); *Pictures from Life in Field and Fen*; *Idylls of the Norfolk Broads*; *Wild Life on a Tidal Water*. His book *Naturalistic Photography* was published in three editions, the first in 1889. Important features of his photography are the use of selective focusing (thematically central features are sharply defined, surrounding areas are soft edged) and viewpoint selection. Many of the people in his photographs are depicted in motion although there must have been pre-arrangement in positioning.

Aspiring practitioners of the art of photography turned away from the contrived situation to the natural scene with relief. Shorter exposure times (gelatino-halide emulsions) and smaller cameras permitted greater flexibility and mobility.

Frank Meadow Sutcliffe

One of the most distinguished of the Naturalistic photographers, Frank Meadow Sutcliffe was a professional portrait photographer from 1875–*c*1920, who established a studio in the seaside town of Whitby. The business was seasonal although there was a small trickle of local clients during the winter months. To add to his income Sutcliffe photographed Whitby, its inhabitants, and its environment. Harold Hood, a fellow photographer, called him 'the pictorial Boswell of Whitby'. Many of Sutcliffe's photographs were exhibited in the major exhibitions in the form of carbon or platinum prints. He preferred large format cameras and collodion plates to the faster but less certain gelatino-halide process and small hand cameras. Groups of fisherfolk on the quayside and small boys playing in the harbour were asked to remain still while the photograph was taken. He waited for the right moment rather than posing people deliberately.

Other distinguished Naturalistic photographers were G Christopher Davies, J B B Wellington, and B Gay Wilkinson.

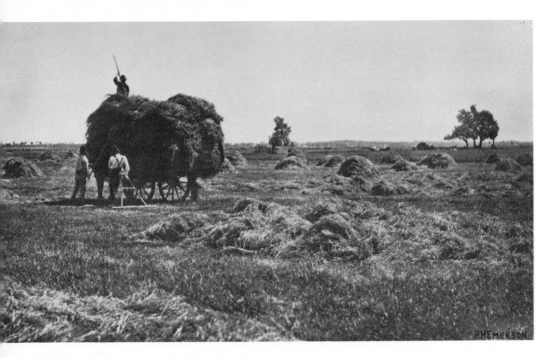

64 DR PETER HENRY EMERSON *The Haysel* 1887. One of twelve photographs printed as autogravures (hand photogravures) direct from the negatives and published in a limited edition portfolio *Idylls of the Norfolk Broads.* $10'' \times 5\frac{1}{2}''$, dark brown

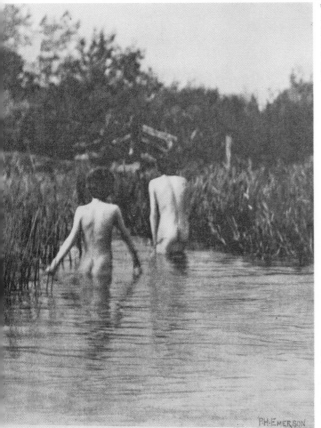

65 DR PETER HENRY EMERSON The *Water Babies* 1887. One of twelve photographs printed as autogravures (hand photogravures) direct from the negatives and published in a limited edition portfolio *Idylls of the Norfolk Broads.* $4\frac{3}{4}'' \times 6\frac{1}{4}''$, warm black

66

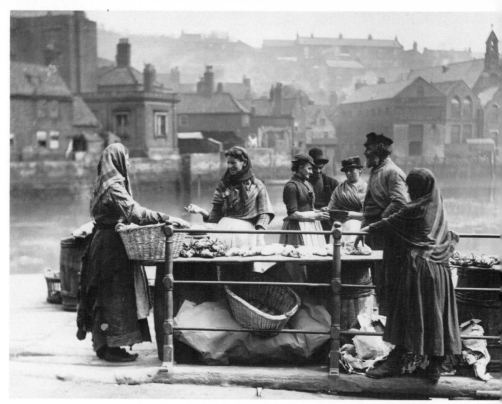

67

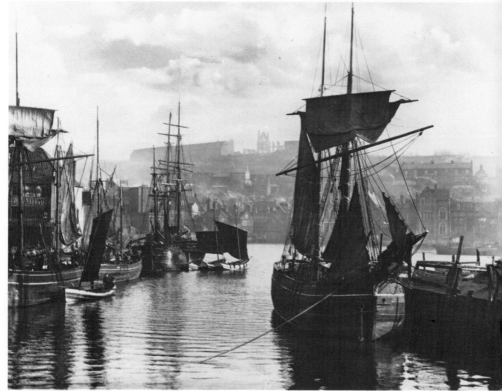

Impressionistic Photography c1890–c1914

SOME PHOTOGRAPHERS took Emerson's ideas of 'sharp-soft' imagery much further than he could accept. In attempts to obtain impressions rather than detail photographers, led by **George Davison** in Britain—a keen and talented amateur photographer who was Managing Director of Kodak Limited between 1892 and 1907—and **Watzek** and **Henneberg** in Vienna, introduced diffuse imagery by the use of pin-holes in place of lenses, diffusion discs, and soft focus lenses. **Robert Demachy** in Paris, **Alfred Maskell** and **Horsley Hinton** in London promoted manipulative control of the medium, extending the imagery well beyond the purely photographic. Re-touching on negative and print was extensively employed and printing processes such as Gum Bichromate, Oil Transfer, and Bromoil enabled the photographer to change tonal relationships and to subdue or emphasise detail. Many of these photographs look like charcoal drawings or lithographs.

The Secessionist Movement 1891–c1914

THE PURSUIT of artistic excellence in the use of the medium led to the formation of exclusive groups, the members of which practised **Pictorial Photography** and exhibited their work on the same basis as painters. Groups were formed in Vienna and Brussels in 1891; the Linked Ring Brotherhood (international membership by election) was established in 1892 in Britain; the Photo Club of Paris formed a Secessionist Group in 1894; and Alfred Stieglitz was responsible for the formation of the Photo-Secession (American photographers only) in the USA in 1902.

Frederick Evans

A member of the Linked Ring-Brotherhood, Evans was formerly a bookseller who became a professional architectural photographer between 1905 and 1940. He was a purist to whom retouching and print manipulation were taboo. One of the finest exponents of architectural photography, Evans emphasised mood, atmosphere, spatial relationships, and conveyed height and depth in his photographs in a manner seldom equalled, let alone surpassed. His rare portraits and fine landscapes also have exceptional qualities. There is an increasing interest in his work.

66 FRANK MEADOW SUTCLIFFE *New Quay fish stall. Whitby c1877.* Reproduction is from a modern print made from the original $8\frac{1}{2}'' \times 6\frac{1}{2}''$ collodion negative. Sutcliffe used the carbon printing process for making his prints. *By courtesy of Bill Eglon Shaw*

67 FRANK MEADOW SUTCLIFFE *Dock End 1880.* A view of Whitby Harbour with schooner *Alert* at right. Reproduction is from a modern print made from the original $8\frac{1}{2}'' \times 6\frac{1}{2}''$ collodion negative. *By courtesy of Bill Eglon Shaw*

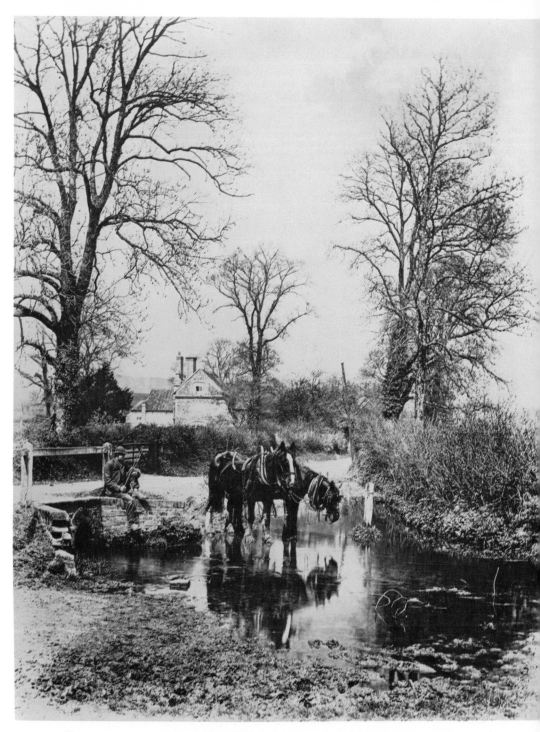

68 COLONEL JOSEPH GALE *Sleepy Hollow, Crossways Farm, Abinger* c1889. Reproduction is from a P.O.P. print 8″ × 10″. One of the Realist group of pictorial photographers, examples of his work were reproduced in gravure in the *Sun Artists* publication in 1891

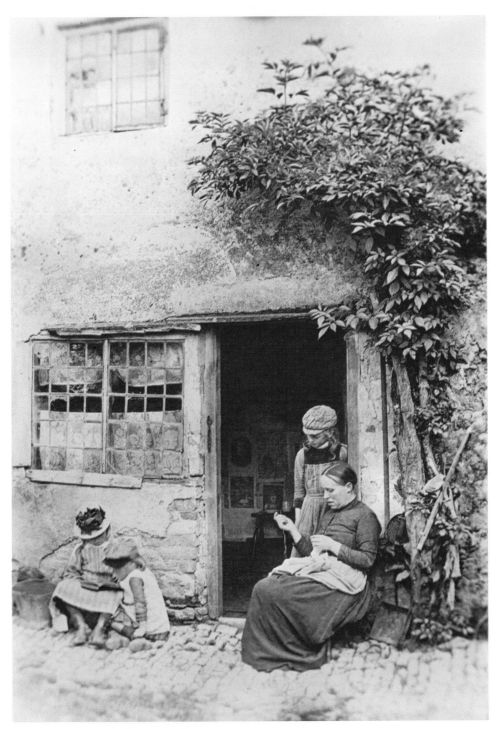

69 ATTRIBUTED TO COLONEL JOSEPH GALE probably taken around 1886 for his series: Figures in Doorways. P.O.P. print $6\frac{1}{2}'' \times 9\frac{1}{2}''$

72 JOSEF SUDEK *Panoramic study of houses in the old city of Prague* 1959. Bromide print $11\frac{1}{4}'' \times 3\frac{1}{2}''$ (p41)

70 FREDERICK H EVANS *Ely Cathedral: South West Transept to Nave* 1901. Platinum print $5'' \times 8''$. *In the collection of T Herbert Jones ARPS*

71 CHARLES JOB *The Thames below London Bridge* c1905. Carbon print $13\frac{1}{2}'' \times 10\frac{1}{2}''$. Job was a pictorial photographer and a member of the Linked Ring. He specialised in romantic landscapes, water and street scenes, frequently including dramatic skies. *In the collection of T Herbert Jones ARPS*

70

Alvin Langdon Coburn

Coburn was another distinguished pictorialist and a member of both Linked Ring and Photo-Secession. A fine visual interpreter of the cities of London and New York and the rugged North American scenery, his photographs of eminent men of the literary and visual arts, taken in the first twenty years of the twentieth century, are outstandingly good portraits. For his publication *Men of Mark* he made his own photogravure plates and the master prints. He became involved with the Vorticist Movement and in 1917 made a Vortoscope, producing abstract photographs with it which he called Vortographs.

73 ALVIN LANGDON COBURN *W H Davies* 1913. A portrait published in *More Men of Mark*

Straight Photography c1914–c1940

THE FIRST World War introduced a cold note of reality into everyday life. Photographers moved away from the beautiful, the romantic, and the mysterious. The veil was lifted and subjects were presented with clarity and reality rather than idealistically. People in photographs looked with steadfast gaze towards the camera, and photographers explored a close-up range of natural objects and patterns formed by man-made objects never before attempted. Foremost amongst these photographers were *James Craig Annan, Malcolm Arbuthnot* and *Ward Muir* of Britain; *Paul Strand, Edward Weston,* and *Ansel Adams* of America; *Albert Renger-Patszch, Auguste Sander, Hugo Erfurth* and *Erna Lendvai-Dircksen* of Germany. Pictorialism maintained its firm hold in the amateur field until the Second World War.

Care and Conservation

OLD PHOTOGRAPHS should be handled with care (moist fingers are a source of acid contamination injurious to delicate images) and kept away from strong daylight and artificial light which emits ultra-violet rays. They should be stored in a temperature of 56°F–66°F (no higher than 70°F) and relative humidity between 30% and 50%. Extremes are injurious, excessive heat and dryness will crack paper which disintegrates rapidly, as will leather likewise. Very moist atmospheres (worst when combined with heat) will encourage mould and fungus growths. Staining and fading of the image from the activities of these micro-organisms can occur.

Contamination by sulphur compounds in the atmosphere can cause fading of the image and is especially injurious to daguerreotypes, leading to tarnishing of the silver plate. It also produces bronzing effects in bromide prints and negatives if materials were inadequately fixed or washed.

The use of mountants, fixatives, and self adhesive tapes should be avoided. If desired, prints should be dry mounted as the adhesive tissue is chemically inert and protects the print from contact with acids, if any, in the mounting board. Glassine should not be used for storage envelopes. Photographically inert acetate can be used as an enclosure. A polyester transparent film is safe for the storage of photographs and sleeves made from this material can be obtained from Secol, Thetford, Norfolk, or Kodak Limited. Sleeves will protect prints and negatives from surface abrasion.

To avoid excessive weight and pressure most print material is best stored horizontally on shelves of restricted space in a metal cupboard with the doors opened from time to time to permit air circulation. Some woods have toxic properties and all are best avoided for storage purposes. If boxes are used for loose prints avoid cardboard which has a high acid content. Ryder and Sons of Bletchley, Bucks, supply suitable boxes for museum as well as for private use.

Restoration of old photographs

is sometimes possible but requires expert advice.

Colour Photographs

There is a noticeable inertia in respect of collecting colour photographs, probably due to problems of instability and fading, although some of the early processes such as Autochrome and Finlay Colour have survived remarkably well.

Motion Photographs

Unfortunately, space does not permit the inclusion of photographic experiments leading to the invention of motion pictures—which perhaps are of greater interest to students of film history.

Modern Prints from Old Photographs

IN CERTAIN instances modern prints can be made from the original negatives, in which case a fine collection of images can be made for a comparatively small outlay. Originals of the following can be obtained:

Frank Meadow Sutcliffe (Bill Eglon Shaw, the Sutcliffe Gallery, Flowergate, Whitby, Yorks)

Thomas Annan (T & R Annan and Son Ltd., 130 West Campbell Street, Glasgow, Scotland)

A Renger-Patzsch (Sabine Renger-Patszch, 4773 Mohnsee Wamel-Dorf 15, Germany)

The Photographers Gallery, 8 Great Newport Street, London WC2 have a Print Room from which photographs, historical and modern, may be purchased. New prints made direct from original negatives to the highest specifications are also available in some instances.

The Royal Photographic Society supplies copy prints of the photographs in the Society's collection in various formats and qualities, suitable for study purposes, reproduction or display and exhibition.

Galleries which regularly exhibit Photographs in Britain

LONDON

B2, Wapping Wall, London, E2. Tel.: 01-488 9815

Camden Arts Centre, Arkwright Road, London, NW3. Tel: 01-435 2643

Camerawork, 121 Roman Road, London, E2. Tel: 01-980 6256/7/8

Camera Club, 8 Great Newport Street, London, WC2. Tel: 01-240 1137

Contrasts Gallery, 19 Dover Street, London, W1

Critical Eye Photo Gallery, 22 Maddox Street, London, W1. Tel: 01-629 5095

Fingerprints Gallery, 329 The Broadway, Muswell Hill, N10. Tel: 01-883 5502

Goldfinger Gallery, 329 The Broadway, Muswell Hill, N10. Tel: 01-883 5502

Hamilton Gallery, 13 Carlos Place, W1

Imperial War Museum, Lambeth Road, London, SE1. Tel: 01-735 8922

Institute of Contemporary Arts, The Mall, SW1. Tel: 01-930 3647

Keith Johnson Photographic Ltd, Ramilies House, 1–2 Ramilies St, London, W1. Tel: 01-439 8811

Kodak Photographic Gallery, 190 High Holborn, London, WC1

Moira Kelly Ltd, 97 Essex Road, Islington, London, N1 Tel: 01-359 6429

Museum of London, London Wall, London, EC2. Tel: 01-600 3699

Museum of Mankind, Ethnography Department of the British Museum, 6 Burlington Gardens, London, W1. Tel: 01-437 2224

National Maritime Museum, Greenwich, London SE10. Tel: 01-858 4422

National Portrait Gallery, St Martin's Lane, London, WC2. Tel: 01-930 1552

Olympus Cameras Centre, The Ritz Colonnade, 151 Piccadilly, London, W1

On the Wall Gallery, 60 Chalk Farm Road, London, NW1. Tel: 01-267 4223

Orleans House Gallery, Riverside, Twickenham

Photographers' Gallery, 5 & 8 Great Newport Street, London, WC2. Tel: 01-240 5511

Photographic Information Centre, 84 Newman Street, London, W1. Tel: 01-323 4641

Polytechnic of Central London, The Regent Gallery, 309 Regent Street, London, W1. Tel: 01-580 2020

Polytechnic of Central London, The Concourse Gallery, 35 Marylebone Road, NW1

PTC Night Gallery, 52–54 Kenway Road, Earl's Court, London, SW5. Tel: 01-629 5069

Serpentine Gallery, Kensington Gardens, London, W2

Science Museum, Exhibition Road, London, SW7. Tel: 01-589 3456

Victoria and Albert Museum, The Cole Building, Exhibition Road, London, SW7. Tel: 01-589 6371

Whitechapel Art Gallery, Whitechapel High Street, London, E1. Tel: 01-377 0107

OUTSIDE LONDON

ABERYSTWYTH: Arts Centre Gallery, University College of Wales

BATH: National Centre of Photography, The Royal Photographic Society, The Octagon, Milsom Street. Tel: 0225 62841

BRADFORD: National Museum of Photography, Film and Television (opening in 1983)

BRISTOL: Arnolfini Gallery, Narrow Quay. Tel: 0272 299191

CARDIFF: Photographic Gallery, 41 Charles Street. Tel: 0222 41667
Photographers' Corridor, University College, Main Building, 1st floor. Tel: 0222 44211

CHIPPING NORTON: Kedros Gallery, 35 West Street, Oxfordshire. Tel: 0608 2973

DERBY: Art and Design Concourse, Derby Lonsdale College, Keldeston Road

EASTBOURNE: Towner Art Gallery, Manor House, 9 Borough Lane

EDINBURGH: Stills Gallery, 58 High Street

GLASGOW: Third Eye Centre, 350 Sauchiehall Street

HARROW, MIDDLESEX: Kodak Museum, Headstone Drive

HULL: The Posterngate Gallery, 6 Posterngate. Tel: 0482 24813

KENDAL: Brewery Arts Centre, Highgate, Kendal. Tel: 0539 25133

LACOCK: Fox Talbot Museum, Lacock, Chippenham, Wilts. Tel: 024973 459

LEICESTER: Leicestershire Museum and Art Gallery, New Walk

LEIGH, GREATER MANCHESTER: Turnpike Gallery

LIVERPOOL: Open Eye Gallery, 90–92 Whitechapel. Tel: 051-709 9460

NEWCASTLE-UPON-TYNE: Side Gallery, 9 Side. Tel: 0632 22208
Spectro Gallery, Bell's Court, Pilgrim Street. Tel: 0632 22410

NOTTINGHAM: Trent Polytechnic, School of Art and Design, Dryden Street

OLDHAM: Uppermill Photographic Gallery, Library, Saddleworth. Tel: 061-678 4651

OXFORD: Museum of Modern Art, 30 Pembroke Street. Tel: 0865 722733

PLYMOUTH: Arts Centre, 38 Looe Street. Tel: Plymouth 660060

SOUTHEND: Mostly Photographic Gallery and Workshop, 10/11 Market Place, off Alexandra Street. Tel: 0702 352784

ST. LEONARD'S-ON-SEA: Photogallery, The Foresters Arms, Shepherds Street. Tel: 0424 440140

WHITBY: Sutcliffe Gallery, 1 Flowergate

WIGAN: College of Technology, Photographic Gallery, Library Street Building

YORK: Impressions Gallery, 17 Colliergate. Tel: 0904 54724

Also many museums and art galleries throughout Britain display photographs at intervals.

Picture Research

The National Photographic Record (c/o The Royal Photographic Society) contains references to public and private collections in Britain, the majority of which are documentary in nature.

Most State Historical Societies in USA have collections of photographs of local, documentary interest, usually archived with other print material.

Some Important Collections of Photographs

Britain

LONDON
The British Museum (early photography)
The Museum of London (historical and recent photographs taken in London)
Radio Times Hulton Picture Library, 35 Marylebone High Street (press and photo-journalism)
Imperial War Museum (major collection from World War I onwards)
National Monuments Record (historic buildings including churches, country houses and sculpture in Britain)
National Maritime Museum (historic maritime subjects ie ships)
National Portrait Gallery (portraiture and people)
Royal Anthropological Institute (anthropological subjects)
Royal Geographical Society (exploration, indigenous people)
Royal Institute of British Architects (mainly photographs of buildings of 20th Century)
Science Museum (history of photography: equipment and photographs)

Victoria and Albert Museum (history of photography, including documentary and art photography)

BATH
Royal Photographic Society (history of photography, including documentary and art photography)

BIRMINGHAM
The Reference Library (documentary: local places, customs, crafts, Sir Benjamin Stone's collection)

BRADFORD
National Museum of Photography, Film and Television (history of photography, film and television)

EDINBURGH
Central Library (emphasis on Edinburgh and Scotland, early material including Calotype Club albums, Keith, Inglis, Forbes White photographs)
Scottish National Portrait Gallery (most complete collection of Hill/Adamson calotypes)

HARROW, MIDDLESEX
Kodak Museum (history of photography)

LACOCK, WILTS
Fox Talbot Museum, Lacock Abbey

MANCHESTER
The Local History Library of the Central Library (documentary: architectural, industrial, sociological of Manchester and immediate environment including photographs by Mudd, Brothers, Coulthurst, Wardley)
Museum of Science and Technology (mainly early industrial photography and Dancer microphotographs)

NORWICH
Local History Library of the Central Library (documentary: East Anglian life and Emerson collection)

WHITBY, YORKS
Sutcliffe Gallery, Flowergate (Frank M Sutcliffe collection)

Europe

AUSTRIA
Hohere Graphische Bundes-Lehr-und Versuchsanstalt, Vienna (history of photography, includes J M Eder's collection)
Hans Frank collection, Photomuseum des Landes, Oberösterreich, Bad Ischl (early Austrian and European photography)

BELGIUM
Provinciaal Museum Voor Fotografie, Karel Oomstraat 11, B-2000 Antwerpen (history of photography, emphasis: Belgian photography)

CZECHOSLOVAKIA
The National Technical Museum, Prague (mainly early material and part of Stenger's collection)

DENMARK
The Royal Library, Copenhagen (large documentary collection)

FRANCE
Bibliothèque Nationale, Paris (major documentary emphasis, also separate history of photography section including leading French photographers: Nadar, Carjat, Etienne, Atget, Cartier Bresson, Brassai)
Musée Carnavalet, Paris (photographs of Paris)
Société Française de Photographie, Paris (early French photography)

André Jammes private collection, Saint Germain-des-Pres, Paris (early French and English photography)
Musée Denon, Chalon-sur-Saône (Niépce museum)

GERMANY
Staatliche Landesbildstelle, Hamburg (early German photography)
Agfa-Gavaert Photomuseum, Leverkusen (Stenger's and Wendel's collections, photographs by Erfurth, and Kunst (art) photographs)
Museum fur Photographie, Dresden, East Germany (early photography)

HOLLAND
Stedelijk Museum, Amsterdam (20th-century Dutch art photography)
Prentenkabinet, University of Leiden (Gregoire collection, emphasis on Dutch art photography)

United States of America

CALIFORNIA
Art Division, Oakland Museum (art photography California and the West, including Dorothea Lange collection)

CHICAGO
*The Art Institute (*art photography including Stieglitz, Weston, Strand and collection of woodburytypes)

MADISON, WISCONSIN
State Historical Society of Wisconsin (documentary of small town and rural life in US Middle West. William Jackson collection)

PHILADELPHIA
Alfred Stieglitz Center, Philadelphia Museum of Art at Fairmount (art photography: 19th-century French and English, 20th-century American)

NEW MEXICO
Art Museum, University of New Mexico at Albuquerque (art photography: French, English, American)

NEW YORK
*Metropolitan Museum of Art (*art photography)
Museum of Modern Art (Steichen archives, Atget collection, art photography emphasis 20th-century)
Museum of the City of New York (documentary New York, including Jacob Riis, Byron, Berenice Abbott, Wurts

brothers, Gottscho-Schleisner and *Look* Magazine collections)

ROCHESTER, N.Y.
The International Museum of Photography, George Eastman House (history of photography based on Cromer's collection)

TEXAS
University of Texas at Austin (Gernsheim's collection and 19th and 20th century American photography

WASHINGTON D.C.
Library of Congress (documentary with separate collection of art photography FSA files, W H Jackson, Arnold Genthe and Frances B Johnson collections)
National Gallery of Art, The Stieglitz Archives
National Archives (documentary, mainly exploration surveys from 1860 forward, including Jackson, O'Sullivan, Gardner collections and Brady's Civil War photographs)
National Museum of History and Technology, the Smithsonian Institution (history of photography including complete collection of Muybridge)

Select Bibliography

Only a brief selection of readily available titles has been included.

General

NEWHALL, Beaumont: *The History of Photography*, pub. Secker and Warburg, 1972

GERNSHEIM, H & A: *The History of Photography*, pub. Thames and Hudson, 1969

JEFFREY, Ian: *A Concise History of Photography,* pub. Thames and Hudson, 1981

EDER, Josef Maria: *History of Photography*, trans by E. Epstean, modern edition by Dover, 1978

Photography: the first eighty years, exhibition catalogue, pub. Colnaghi, Bond St, with text by Valerie Lloyd, 1976

The Science Museum Photography Collection Catalogue compiled by D B Thomas, HMSO 1969

From Today Painting is Dead Exhibition catalogue (The Beginnings of Photography) Arts Council of Great Britain, 1972

HOPKINSON, Tom: *Treasures of the Royal Photographic Society*, 1839–1919, pub. RPS and Heinemann, 1980

COE, Brian: *Colour Photography, the first hundred years 1840–1940*, pub. Ash and Grant, 1978

WITKIN, Lee D, & LONDON, Barbara: *The Photograph Collector's Guide*, pub. Secker and Warburg, 1979

Daguerreotypy

GERNSHEIM, H & A: *History of the Diorama and Daguerreotype*, pub. Dover, N.Y., 1971

Calotypy

BUCKLAND, Gail: *Fox Talbot and the Invention of Photography*, pub. Scolar Press, 1980

Portraiture

BRUCE, David: *Sun Pictures (Photographs by Hill and Adamson)*, pub. Studio Vista, 1973

Landscape, Topographical and Travel Documentary Photography

BUCKLAND, Gail: *Reality Recorded*, pub. David and Charles, 1974

Photographic Art

SCHARF, Aaron: *Art and Photography*, pub. Allen Lane Penguin Press, 1968

HARKER, Margaret: *The Linked Ring, the Secession Movement in Photography in Britain, 1892–1910*, pub. Royal Photographic Society and Heinemann, 1979

JONES, E Yoxall: *The Father of Art Photography: O G Rejlander,* pub. David and Charles, 1973

Early Social Documentary Photography

ANNAN, Thomas: *Photographs of the Old Closes and Streets of Glasgow, 1868–1877,* pub. Dover, 1977

THOMSON and SMITH: *Street Life in London, 1877–8,* Reprint by E P Publishing Ltd, 1973

Care and Conservation

Time Life Library of Photography: *Caring for Photographs*, 1973